IMAGES of America
ERIE

April 11, 2013

Midori —

Congratulations on winning the Erie Chamber of Commerce David Stone Scholarship for 2013. Your scholastic achievement, honors, extra-curricular activities, and community service have distinguished you as one of Erie's shining stars.

Good luck to you in your higher education pursuit of a degree in engineering.

Enjoy this book on Erie — the town you represent so well.

Jim Stuvel

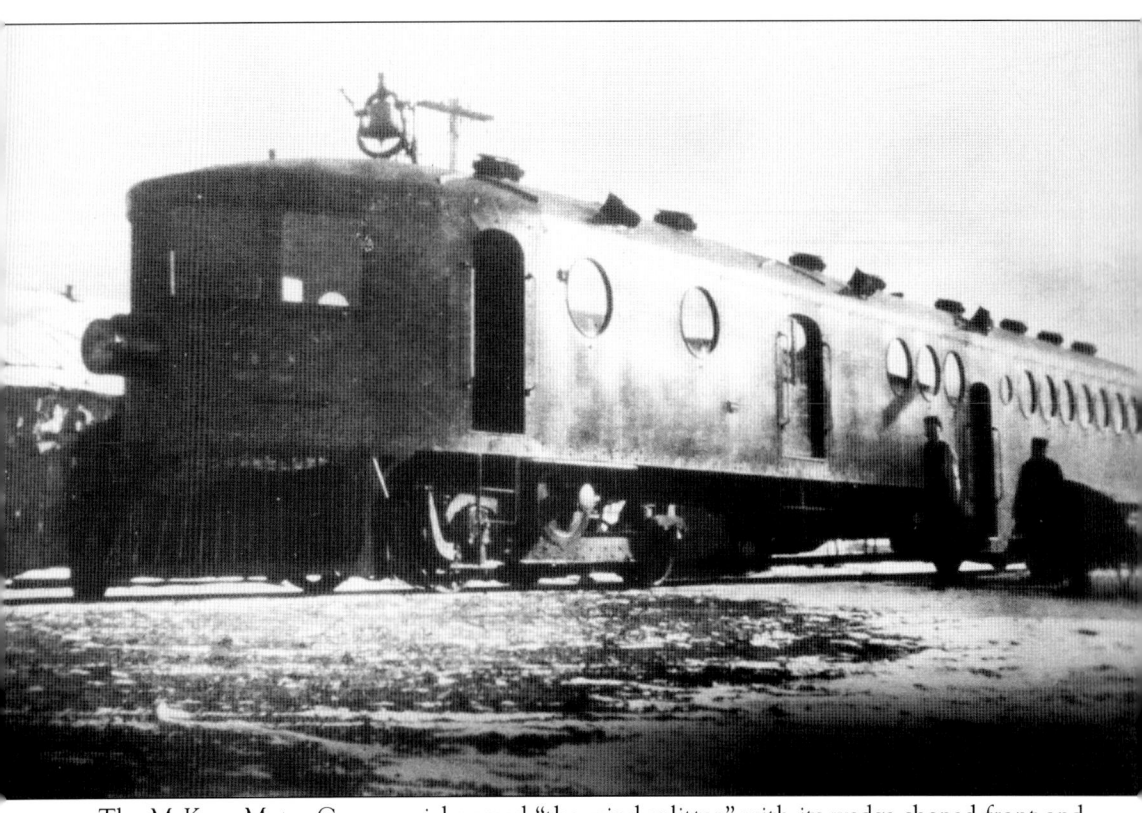

The McKeen Motor Car was nicknamed "the wind splitter," with its wedge-shaped front and porthole windows. The cars were airtight and watertight, with interiors of inlaid Cuban mahogany and hard maple floors. They had triple-wide leather seats and were 55 feet long. (Courtesy Erie Historical Society.)

ON THE COVER: The McKeen Motor Car was a gasoline-powered passenger car that ran on Union Pacific tracks, connecting Erie, Brighton, Boulder, and Denver. It ran from 1905 until 1925 and accommodated 75 people comfortably. (Courtesy Erie Historical Society.)

IMAGES of America
ERIE

James B. Stull
for the Erie Historical Society

Copyright © 2011 by James B. Stull for the Erie Historical Society
ISBN 978-0-7385-7616-9

Published by Arcadia Publishing
Charleston, South Carolina

Printed in the United States of America

Library of Congress Control Number: 2011926198

For all general information, please contact Arcadia Publishing:
Telephone 843-853-2070
Fax 843-853-0044
E-mail sales@arcadiapublishing.com
For customer service and orders:
Toll-Free 1-888-313-2665

Visit us on the Internet at www.arcadiapublishing.com

This book is dedicated to the Erie Historical Society.

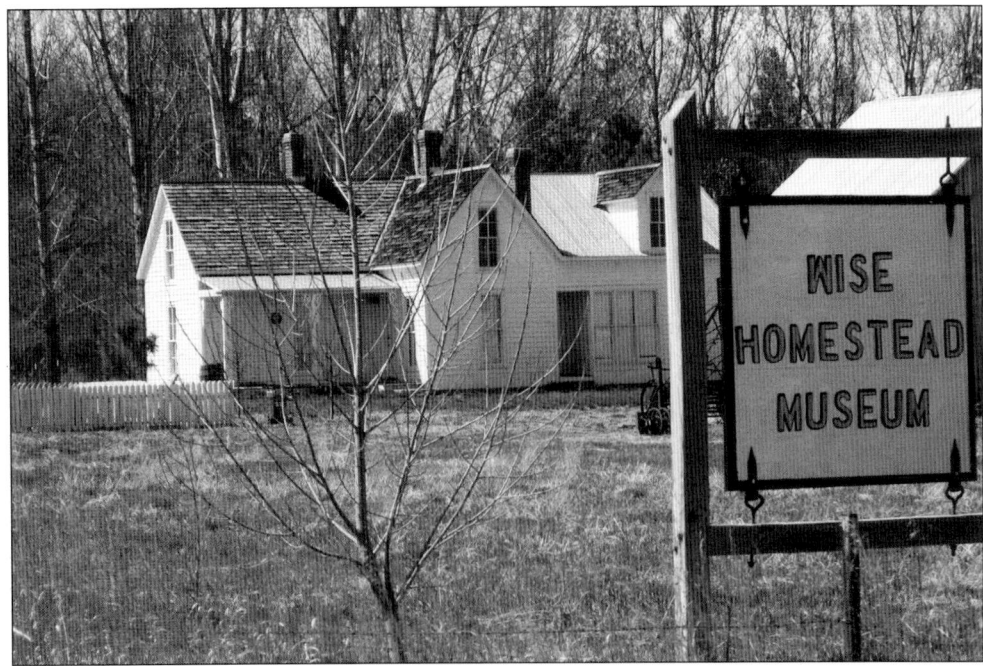

In 1870, Oliver Wise began construction on a permanent farmhouse on his property, after he was granted a US Homestead Patent. It is a Western Victorian and one of the oldest frame houses in Boulder County. Sarah Wise, great-granddaughter of Oliver Wise, worked in concert with the Erie Historical Society to turn the home into a museum, which opened in 2007. (Courtesy Penny Stull.)

Contents

Acknowledgements		6
Introduction		7
1.	In and Around Old Town	11
2.	Pioneers of the Plains	27
3.	Where They Lived, Learned, and Prayed	77
4.	A Claim to Fame	97
5.	The Legacy That Lives On	107
6.	A Great Place to Live	117
Bibliography		127

ACKNOWLEDGMENTS

Images of America: *Erie* was completed only because of the generous contributions of several people. Thanks to all of you for your suggestions, tips, direction, resources, encouragement, and interest in the book.

Dr. Sarah Wise, of the Wise Homestead Museum and Erie Historical Society, showed me many artifacts and antiques that helped me understand Erie's early days. Alan Wise, Sarah's nephew, provided most of the photographs used here. He was also able to identify locations and people in them. John Garcia, of the Erie Historical Preservation Board, directed me toward some of Erie's historical buildings.

Carol Taylor, librarian at the Erie Public Library, suggested several resources for information about Erie and the surrounding region. Her interest in Erie's history and her publications were insightful.

Nancy Parker, Erie's town clerk, provided numerous documents that gave me names and dates associated with Erie's growth.

Others who offered their input at crucial times were Jim Kinne, Jim Dieke, Cammie Arneson, Cheryl Hauger, Steph Meyers, Ralph Castro, Brandon Liley, Mike Muniz, Crystal Thornton, Harold Conroe, Ted Goodwin, Dennis Drumm, Geoff Goble, and Colleen Dame.

Many thanks go to Josh Lopez and John O'Hare for their invaluable assistance in getting the photographs ready for the publisher.

Penny Stull provided many photographs that capture Erie's current state of development.

George Bachelder guided me through a tour of his home, which is a historical museum itself.

Jerry Roberts and Debbie Seracini of Arcadia Publishing fueled my interest and kept me on track throughout the development of this book.

Because history books are based on the accounts of other people, information here may be inaccurate or incomplete. Readers are encouraged to contact the Erie Historical Society with new information or photographs for future research and publications. You may also reach the author at eriecoaldust@yahoo.com.

The Erie Historical Society (EHS) donated most of the photographs in this book; Brandon Liley (BL), Colleen Waneka Dame (CWD), Crystal Thornton (CT), Penny Stull (PS), the Town of Erie (TE), and the National Archives (NA) provided the other images.

INTRODUCTION

Erie, Colorado, is located about 20 miles north of Denver and 12 miles east of Boulder. It is built on dry prairie land.

A brief geology lesson is important to understand the significance of the land surrounding Erie. About 175 million years ago, the earth's North America Plate and the Pacific Plate moved toward each other and caused an upward thrust faulting of huge masses of rock that slid up over the land. This formed what later was known as the Rocky Mountains. About 80 million years ago, a second wave of faulting occurred and created the Front Range and foothills on the eastern side of the Rockies. This process caused large deposits of lignite and sub-bituminous coal to rise closer to the earth's surface, some actually lying on the surface and some lying at varying depths; some was mined at more than 500 feet in what became known as the Northern Colorado Coalfield.

The area where Erie is located today used to be a winter haven for the Arapaho and Cheyenne tribes. It did not suffer the extreme cold, heavy snow, and hurricane-force winds that neighboring states experienced. Boulder Creek and Coal Creek were sources of water. The date is uncertain, but these two tribes left the Minnesota area and, because of their common language group, were able to live together. Each tribe had its own language and preserved its unique customs. The area was a great hunting ground for elk, deer, buffalo, and antelope. Native Americans, black bears, and mountain lions competed for the food sources; the tribesmen brought back hides for clothing and tents. Raiding parties from the Ute tribe occasionally ventured into the area in search of horses and women; they battled with the Arapaho and Cheyenne. A few early farmers and merchants also inhabited the countryside. Some of the white settlers who had migrated from the eastern United States or Europe recognized coal lying on the ground and used it to heat their homes. The Cheyenne and Arapaho discovered coal would burn for a long time, but they never incorporated it into their lifestyles.

The first white people in Colorado were likely fur traders and explorers. In 1858, gold was discovered on Pike's Peak, and more than 100,000 people rushed to Colorado from all over the nation and the world to seek their fortunes. The Homestead Act of 1862 encouraged people to move west, claim land, construct a building on it, farm it, and eventually own it. Erie was the home to several homesteading families, with well-known names as Wise, Plumb, Daily, Smith, Carr, Liggett, Marfell, Pease, Kempton, Leyner, Hauck, Prince, Tyler, Delechant, Beasley, and Miller. Still others moved west to escape from crowded cities in the eastern United States, to attend to their health, and to avoid the impending Civil War between the North and South. As white settlers moved in, the Cheyenne and Arapaho moved into even more rural areas. Eventually, Native Americans were driven out of Colorado. One of the most famous incidents was the Sand Creek Massacre of 1864, when about 700 men from the Colorado militia attacked a village of Cheyenne and Arapaho in what is now known as Kiowa County. Today, very few Native Americans live in Colorado, most having relocated to reservations in Oklahoma and Wyoming.

Some settlers in Colorado were more aggressive about mining coal. In Erie, Jim Baker began mining in what he called "Baker's Bank." His mine is believed to have been located just east of Erie above Coal Creek. Jim was an Indian scout who did not stay in the area for very long. He rode with Gen. George Custer and other famous military leaders; he was also an officer in the Colorado militia. George Gilson, a homesteader and slope miner, discovered a rich coal source east of Erie in the early 1860s, which he later traded to Capt. Ira Austin. In 1866, Austin discovered a coal vein and immediately opened Colorado's first official coal mine. As more people turned to mining, Gilson reminded the community that only if the railroad came to Erie would mining become profitable. More industrious miners would haul wagonloads of coal into Denver to sell to the power plant and railroads. Once word spread about coal in Erie, miners and others came from Europe and the eastern United States to work in the mines and operate businesses to support the community.

Erie's population grew and businesses were established. Soon, Erie gained the reputation of being one of the liveliest towns in the Boulder Valley. Saloons lined Briggs and Kattell Streets. Various stores sold clothing, furniture, groceries, mining equipment, and other necessary items. Services included livery stables, blacksmiths, doctors' and dentists' offices, wagon makers, undertakers, transfer services, stage stops, and more. As schools were built, teachers came to the area. Preachers and priests served the various denominations of worshipers. Erie had several newspapers over the years. Gambling casinos and brothels were also popular. Erie was established as a town in 1874, two years before Colorado was admitted to statehood.

The Northern Colorado Coalfield contained nearly 200 mines. About 40 mines were within Erie's reach, and miners found their way to them to work every day. Erie miners traveled as far as Broomfield, Lafayette, Louisville, Frederick, Firestone, Dacono, Thornton, and other neighboring towns to earn their living. Erie soon became the greatest producer of lignite coal in Colorado, with the Columbine Mine leading all others. The introduction of the first railroad spur into Erie led to greater opportunities for mine owners. Now, more coal could be transferred to Denver and other communities. Other railroads followed suit, connecting Erie to Longmont and Boulder. Some railroads were used to haul coal and other freight; others were established to transport people from town to town. Occasionally, Coal Creek flooded and washed out bridges, roads, and railroad tracks.

As with many industries, tensions mounted between miners and mine owners and operators. Mine owners believed they could use miners in any way they wanted. They likely believed that miners should be thankful they had jobs. Miners did not like the conditions under which they were forced to work. The air quality in the mines was poor, with gases and coal dust polluting miners' lungs. Mine cave-ins and explosions killed some miners; others were crushed by coal cars. The mines were structurally unsafe. Weigh bosses typically short-changed miners on how much coal they extracted from the mines. Miners were paid in scrip, which had to be used at company stores that charged higher prices than stores in town that stocked the same supplies and equipment. Miners also wanted more input into managerial decisions that impacted their jobs. When miners did not receive the attention they wanted concerning their grievances, they typically went on strike. Besides striking, some miners actually engaged in the destruction of mine property. Some even went so far as to set off explosives at the mines.

Because miners yearned for resolution of their problems, unions had no problem gathering support in the Northern Colorado Coalfield. At various times, the Knights of Labor, the Western Federation of Miners, the United Mine Workers Association, the Miners National Association, and the Industrial Workers of the World captured the attention of Colorado's miners. Unions and striking miners were looked down upon by mine owners, law enforcement officials, government officials, and even local farmers. They were often called trouble makers, socialists, and communists. While some concessions were made about wages and working conditions, they were typically paltry and taken away from the miners after they were given to them.

In the Southern Colorado Coalfield at Ludlow, north of Trinidad, conditions reached a level that brought United Mine Workers Association organizers into the area, including Mother Jones,

in 1913. About 1,200 miners struck against Colorado Fuel and Iron, a company owned by John D. Rockefeller. He was an absentee owner who had little idea of working conditions at Ludlow and gave orders to mine operators about how to conduct business there. Because the conditions the miners were striking about were not met by management, miners went on strike. The strike lasted into 1914, when on April 20, it escalated into an attack on miners by the Colorado National Guard. The Guard fired weapons that killed three union leaders, two miners, one child, and one bystander. The Guard then torched the tent city that housed miners and their families, resulting in the asphyxiation of two women and 11 children. The aftermath of this incident was the arming of miners and a continuing battle between them and the militia. Some 200 people died from these skirmishes. United Mine Workers leader John Lawson was imprisoned for murder because of his involvement. Officiators of the trial had no sympathy for miners. The guardsmen involved were not convicted of any wrongdoings.

Following the Ludlow incident, other strikes and violence occurred throughout Colorado, particularly in Lafayette and Louisville in the Northern Field. Erie miners often found themselves participating in these events. The results were often the same; miners were found guilty, while others were found innocent.

Erie's Columbine Mine was owned and operated by the Rocky Mountain Fuel Company. The mine had its own housing camp called Serene. The company's owner, Josephine Roche, was sympathetic toward miners' concerns about their working conditions, but she was not yet in any position to make significant improvements to address those concerns. Of course, this caused others with interest in the company to sell their stock. Eventually, Roche bought out other stockholders and gained controlling interest. In 1927, the Industrial Workers of the World (IWW or "Wobblies") organized the largest strike in Colorado's mining history. All of Northern Colorado's approximate 4,500 mine workers went on strike. The timing of the strike was crucial, as it was during the colder months when coal was in greater demand. The only mine that was operating in Colorado at that time was the Columbine Mine. Normally, Columbine employed about 350 miners, but during the strike, about 100 scab laborers kept the mine operating. Roche authorized the regular miners to strike.

Each day, union leaders and strikers paraded to the Columbine Mine at Serene, protested at the gate, marched to Serene's post office, and left the mine premises in a relatively orderly fashion. However, as mine guards and strikers exchanged taunts, the situation became tenser. Colorado's governor appointed Louis Scherf to head a special militia group of rangers to handle any disturbances at Columbine. More IWW union members and representatives converged upon Columbine to support the miners. Each day, many Wobblies were arrested. The mine guards began to prepare for battle. Scherf ordered hard hats for his team of about 20 rangers. Guards installed two or three machine guns, one each on the water tower, the tipple, and possibly the mine head. Additional barbed wire was strung and sandbags were stacked around the perimeter of Serene and the mine. Ordered by Scherf, four planes regularly patrolled the skies over Serene.

On the morning of November 27, between 600 and 1,000 strikers arrived at the gate of Columbine. Without authorization from Governor Adams, Scherf had snuck his team of rangers into the mine during the night. Again, a conflict occurred at the gate between strikers and guards. Following a scuffle, Scherf fired a couple of warning shots into the air. His rangers and mine guards took that as a signal to open fire, and soon, gunshots were ringing out from pistols, rifles, and machine guns. Six miners were killed and about 60 were injured. Doctors attending to the dead and wounded reported removing machine gun bullets from some victims.

Marshall Law was declared in the Northern Colorado Coalfield. Governor Adams deployed 325 National Guardsmen, 45 cavalry, and two tanks to restore peace. Curfews were established; Erie's streets were vacant at night. People needed passes to enter and exit all mines. Planes continued to patrol the skies over Erie and Serene. When this incident reached court, three guards with minor cuts and scrapes showed up heavily bandaged. Showing no sympathy toward the miners, the judge ordered that several miners be jailed in Longmont.

Conditions began to improve once Roche was able to reorganize the leadership of the Rocky

Mountain Fuel Company. She created better conditions for miners and allowed her company to be the first to unionize in Colorado. In 1933, Pres. Franklin D. Roosevelt signed the National Recovery Act that required all coal companies to be unionized.

The history of the coal industry in Colorado is often underplayed or forgotten. The significance of the strikes needs to be chronicled. The results led to more effective labor organization throughout the United States in all industries. Benefits that workers receive today may have taken longer had the nation not paid such close attention to Ludlow and Columbine. Josephine Roche's focus on workers' rights is visible in contemporary management theories and practices in today's most successful companies that place considerable emphasis on concern for both production and people.

Erie's mines began to close after the nation became more dependent upon oil and natural gas. The New Lincoln Mine closed in 1979. When mining disappeared from Erie, the town deteriorated; businesses left the area, and the trees along the streets were not cared for and died.

In the 1990s and up until today, Erie has grown from a town of about 1,000 residents to 19,000 residents. The town has annexed numerous subdivisions and increased its jurisdiction from about 30 square blocks to 48 square miles. Small shopping centers dot the town, and leaders are working to attract businesses to support the increasing population. New schools are being built, and a state-of-the-art water treatment plant is under construction. Today, Erie is a bedroom community that houses those working in Denver, Boulder, and other towns. The town motto is "Your Future is Here." Erie, Colorado, is a great place to live.

One

IN AND AROUND OLD TOWN

Erie's original plat was created in 1871 by officials of the Boulder Valley Mining Company (BVMC). The plat map showed 10 streets running east and west and four streets running north and south. The streets were named after early settlers and BVMC officials. The red-dirt streets were rough and sometimes difficult to navigate in buggies, wagons, and early automobiles. People did not use house numbers for their addresses until much later in Erie's development. Mail was delivered to the post office in Tom Richards's store. People could direct others to "the yellow, two-story house on Pierce Street."

Coal Creek ran east of Erie, near Kattell Street. It flooded several times, washing out roads, railroad tracks, and buildings. Palmer Street is shown on the original plat as crossing the creek, but there is no evidence of it today.

Religion was important to the people; churches were organized. Settlers often belonged to fraternal and social organizations and formed Erie chapters. Among them were the International Order of Odd Fellows, Knights of Pythias, the Maccabees of the World, and more. Even the Ku Klux Klan gained a foothold in Erie.

Homesteaders lived outside of Erie, with many farming wheat, sugar beets, hay, and other crops. While Canfield was a separate town with homesteads and its own stores, many people still traveled to Erie to buy supplies, to attend church or school, and for socialization and entertainment.

Erie once boasted a population of 50 people. Those living in town ran small businesses or provided services. By 1880, the US census counted Erie's population at 358 residents. This was long after coal mining had encouraged people to settle here. With the increase in population, many of the lots on the streets of Erie began to fill with homes, churches, schools, and businesses.

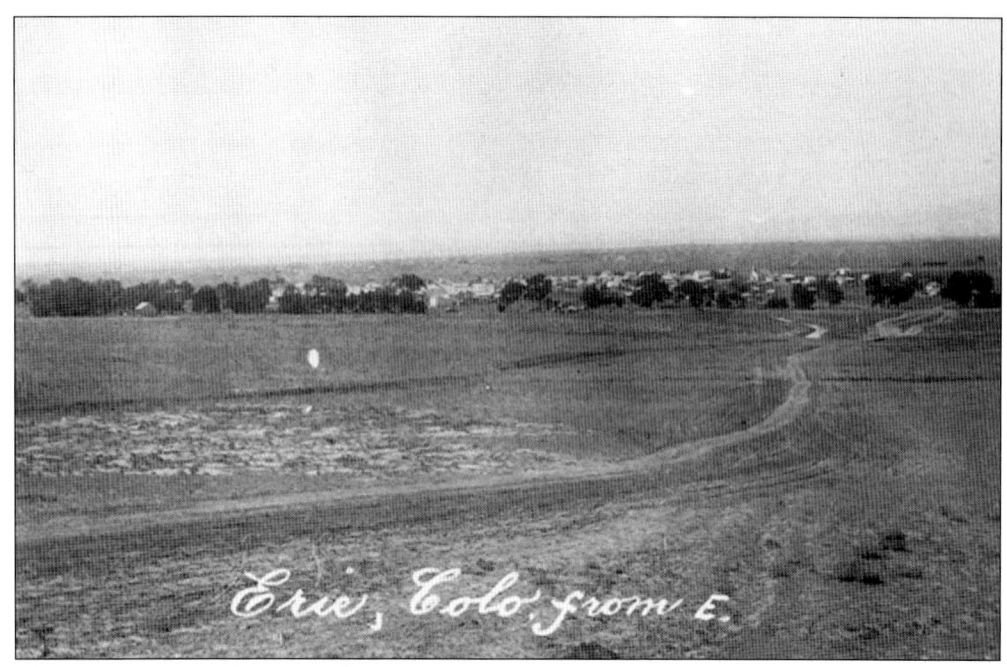

This is a view of Erie from east of town across Coal Creek around the early 20th century. Much of the downtown area was already developed, and trees had grown to substantial sizes. Erie is nestled between ridges emanating from the Front Range of the Rocky Mountains. This site normally provides a panoramic view of the snowcapped mountain tops. (Courtesy EHS.)

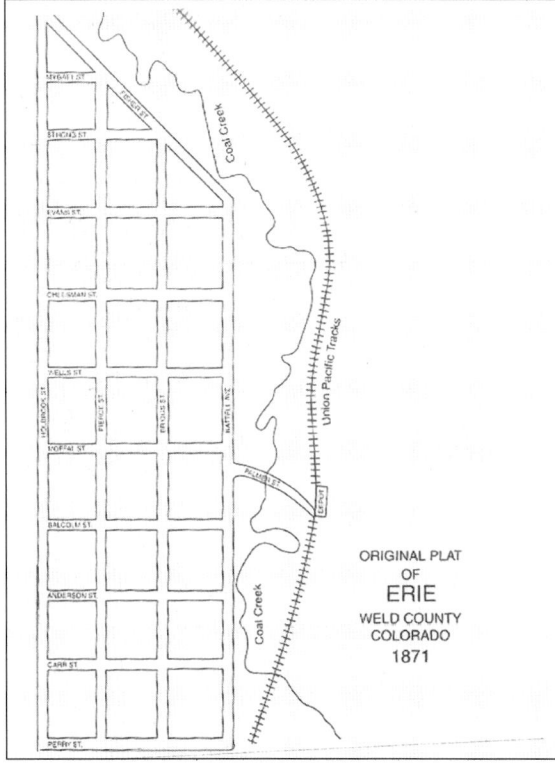

Boulder Valley Mining Company officials drew Erie's original plat in 1871. Erie encompassed four blocks from east to west and eight to 10 blocks north to south; it is suspected the streets north of Evans were never completed. Palmer Street crossed Coal Creek to the train depot and was likely washed out during one of Erie's many floods. (Courtesy TE.)

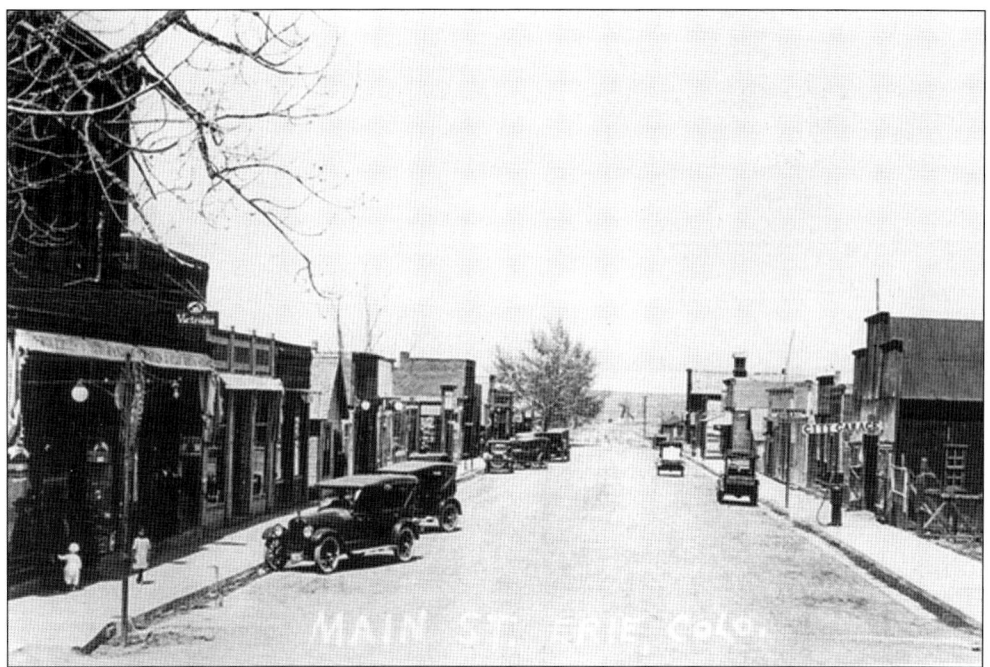

This photograph was taken at Briggs and Moffat Streets, looking north. Charles Elzi's drugstore and Erie Bank are on the left, which suggests this picture was taken in 1912 or later—the year Elzi moved to Erie. More automobiles were appearing on Erie's streets. (Courtesy EHS.)

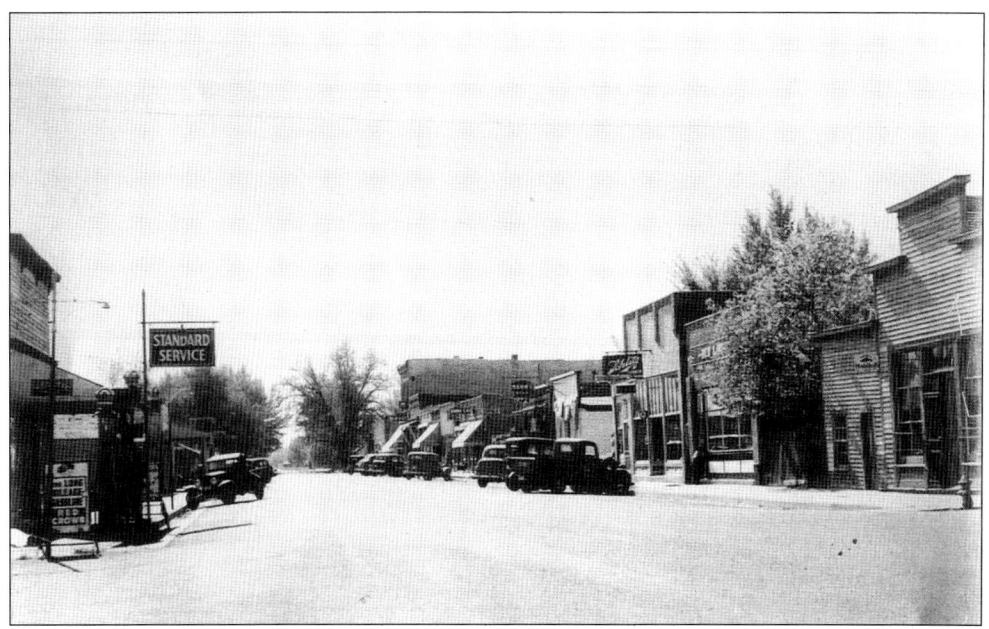

This photograph was taken looking south on Briggs Street at Wells Street. The two-story building in the distance was the site of the International Order of Odd Fellows (IOOF) on the top level and the State Mercantile Company on the bottom level. The Standard Service Station in the foreground was in front of where Erie's first school existed; now, it is the location of Erie's post office. (Courtesy EHS.)

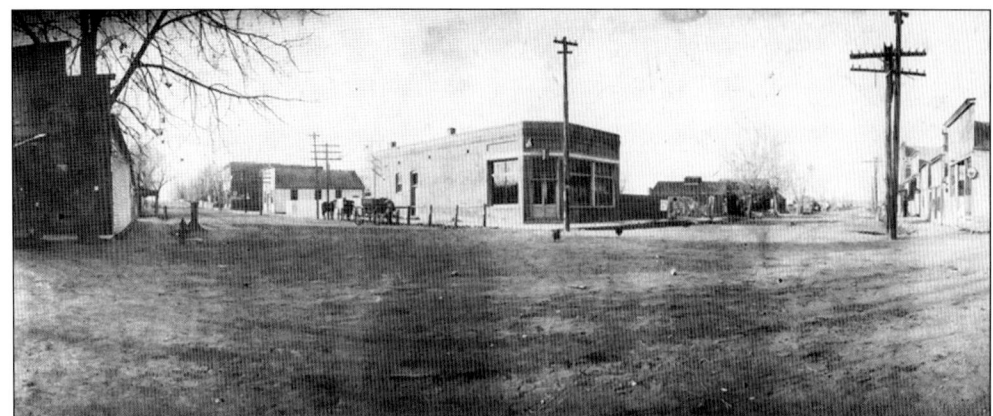

This photograph, taken around 1900, is the northwest corner of Briggs and Wells Streets. The building no longer exists; a different building has served as a church, firehouse, and Erie's first community center. Today, it is the home of the Arts Center of Erie (ACE). J.T. Richards's two-story store is visible in the background on Wells Street. (Courtesy EHS.)

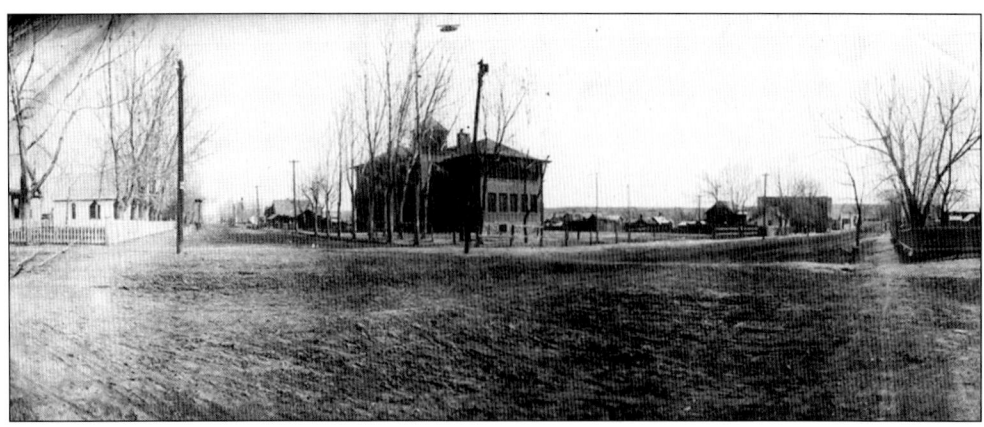

Erie's second school was a brick structure that opened in 1907 on the northeast corner of Holbrook and Wells Street. Called Lincoln School, it replaced Erie's first schoolhouse on Briggs and Wells Streets. Across Holbrook Street to the west is Erie Methodist Church. Down Wells Street to the east is J.T. Richards's store. (Courtesy EHS.)

Erie's fire hose team was no longer pushing a hose cart and running to get to fires once the town purchased a fire engine. These three firefighters were photographed cruising through the intersection at Briggs and Moffat Streets in front of the two-story State Mercantile Company Building. (Courtesy EHS.)

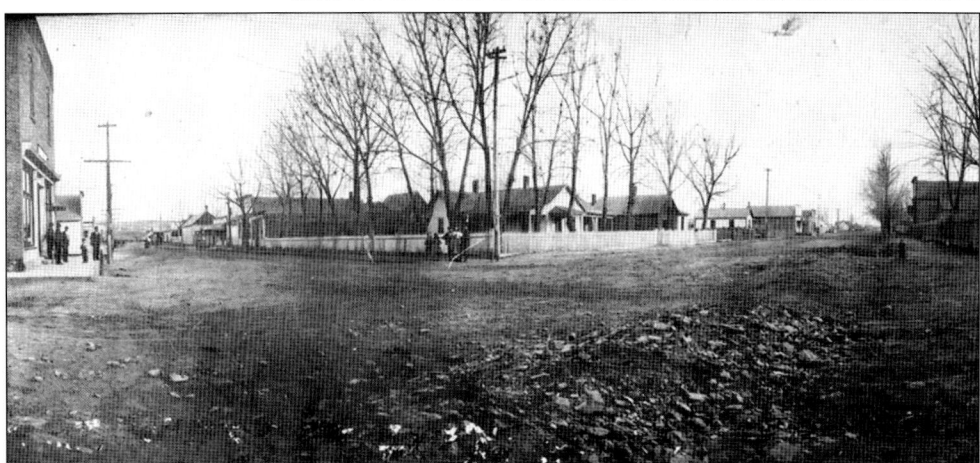

This photograph was taken at Pierce and Wells Streets. People were gathered in front of J.T. Richards's store and across Wells Street. Located south on Pierce Street is the small, white "coffin house" that served as a storage facility for coffins and an overflow classroom for Erie's school. A fire hydrant is visible on the right. The streets in Erie were in constant need of grading. (Courtesy EHS.)

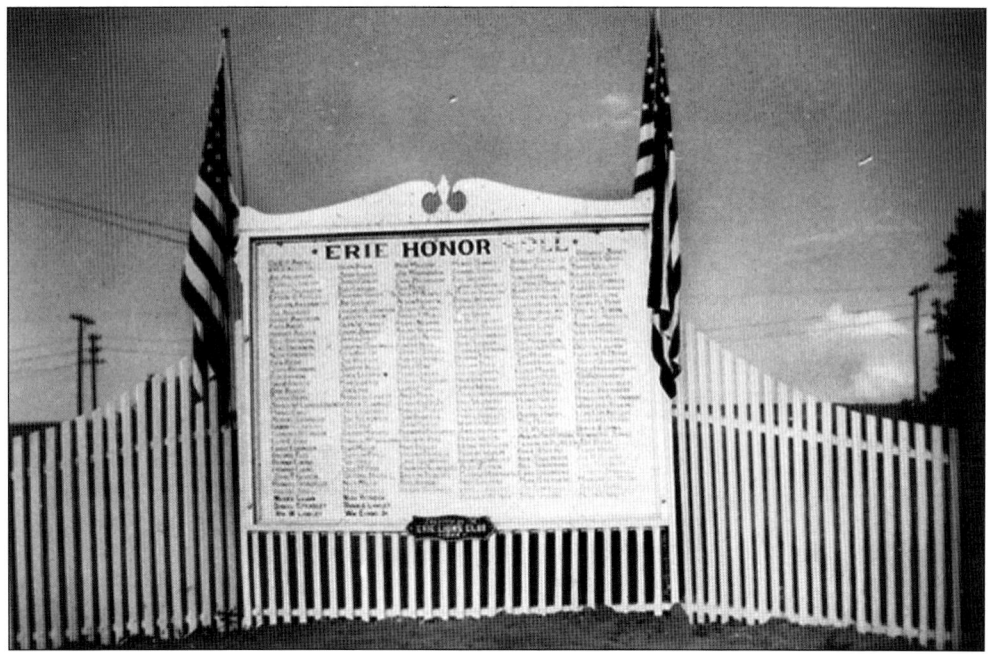

In 1944, Erie's Lions Club erected the Erie Honor Roll sign on the northeast corner of Briggs and Moffat Streets. The sign listed and honored World War II veterans from Erie. The sign is reported to be somewhere in town hall; an effort has begun to install it again in a place of prominence. (Courtesy EHS.)

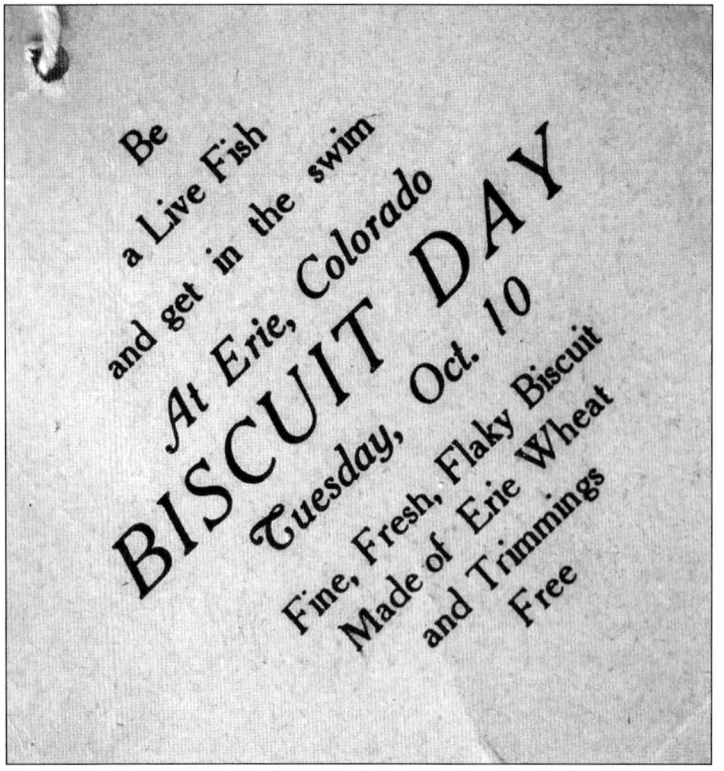

Every October, the local baker, Chris Miller, gave away fresh biscuits with apple butter. People purchased bowls of stew to accompany the biscuits. Ladies ate for free. On this day only, people were allowed to race their horses down Briggs Street. Today, local restaurants provide stew for this resurrected event. (Courtesy EHS.)

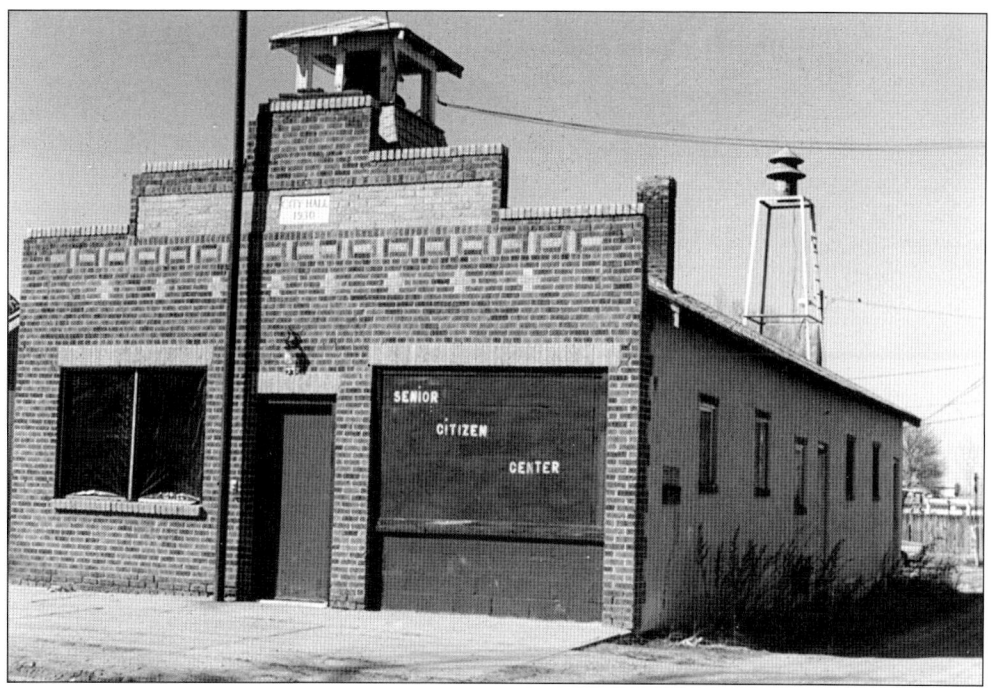
Erie's second Town Hall (here shown as City Hall) served as a senior citizens center after the town government moved into its current location at Holbrook and Wells. Several buildings in Erie were boarded up during a period in the late 1970s, when the last coal mines closed and Erie was considered by many to be a ghost town. (Courtesy EHS.)

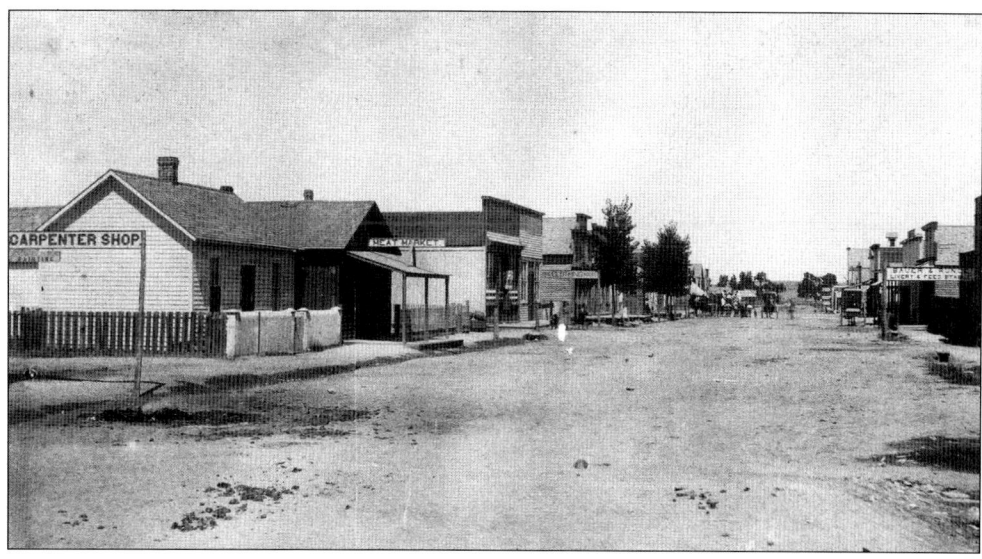
This view is looking north on Briggs Street. Merchants had begun to establish stores. Notice the carpenter shop, meat market, clothing store, and livery and feed stable. The lack of cars, presence of horses and buggies, and the condition of the street suggest this picture was taken in the late 1800s. (Courtesy EHS.)

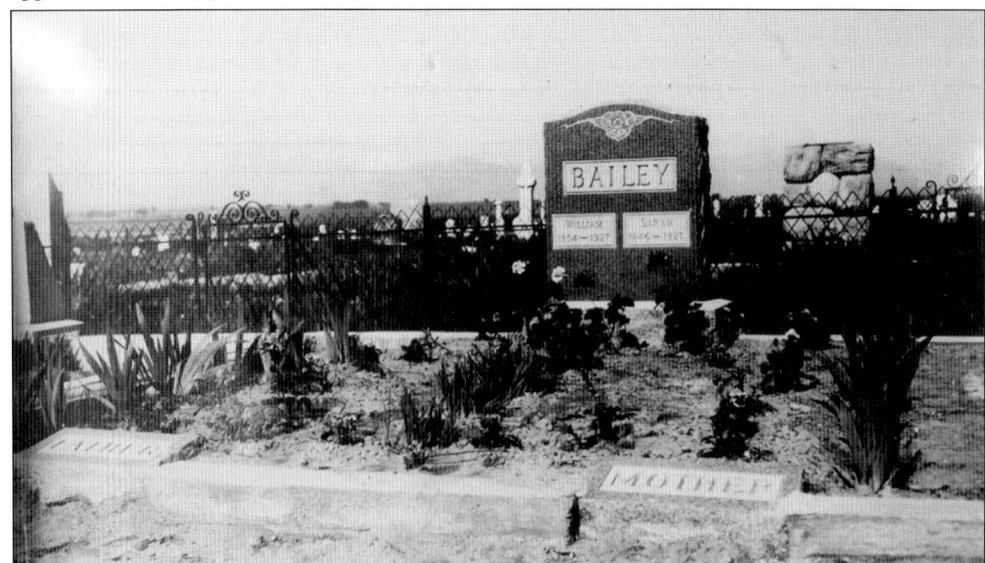

Erie's Mount Pleasant Cemetery is a natural prairie cemetery. No grass or irrigation system has been installed. It offers a beautiful view of Erie and the Rocky Mountains. Possibly hundreds of unmarked graves exist on the hillside west of the cemetery, where people buried their dead in the darkness of night, probably to avoid the costs and associated bureaucracy of obtaining an approved cemetery plot. (Courtesy PS.)

Headstones at the Erie Cemetery chronicle the history of the town. A close look uncovers that many people were buried in sections according to ethnicity. This was done purposely, either by relatives of the deceased or by town officials. Even inside the perimeter of the cemetery, many graves are unmarked, surprising diggers of new gravesites. (Courtesy EHS.)

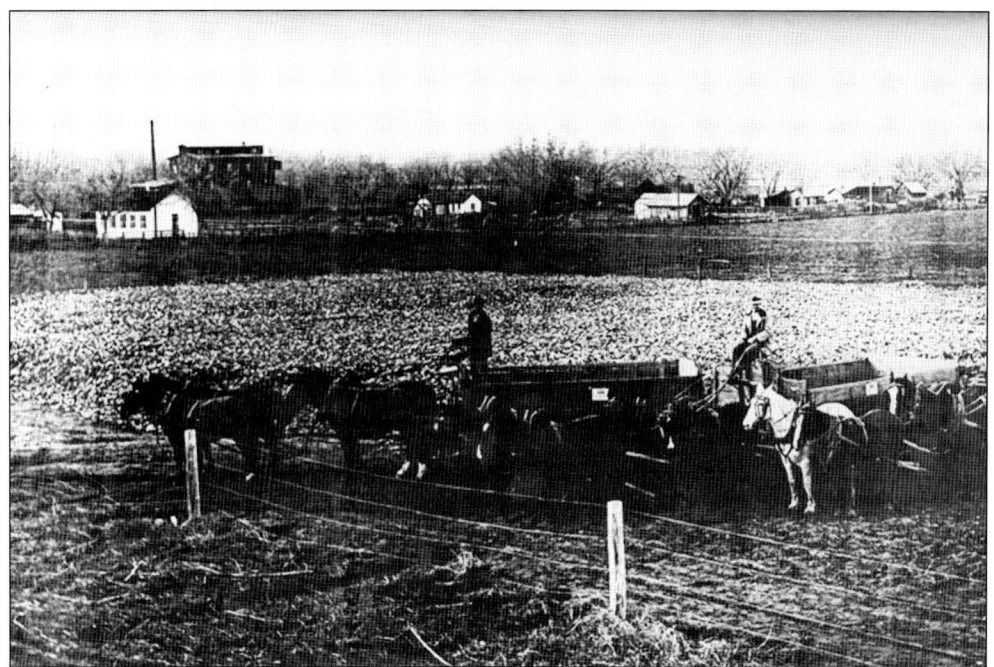

Owners of the Wise Homestead also harvested sugar beets. Through the know-how of German settlers, sugar beets became easier to grow once irrigation canals were established. It was cheaper than using sugar cane from more humid, distant locations. The flour mill and several homestead buildings are visible in the background. (Courtesy EHS.)

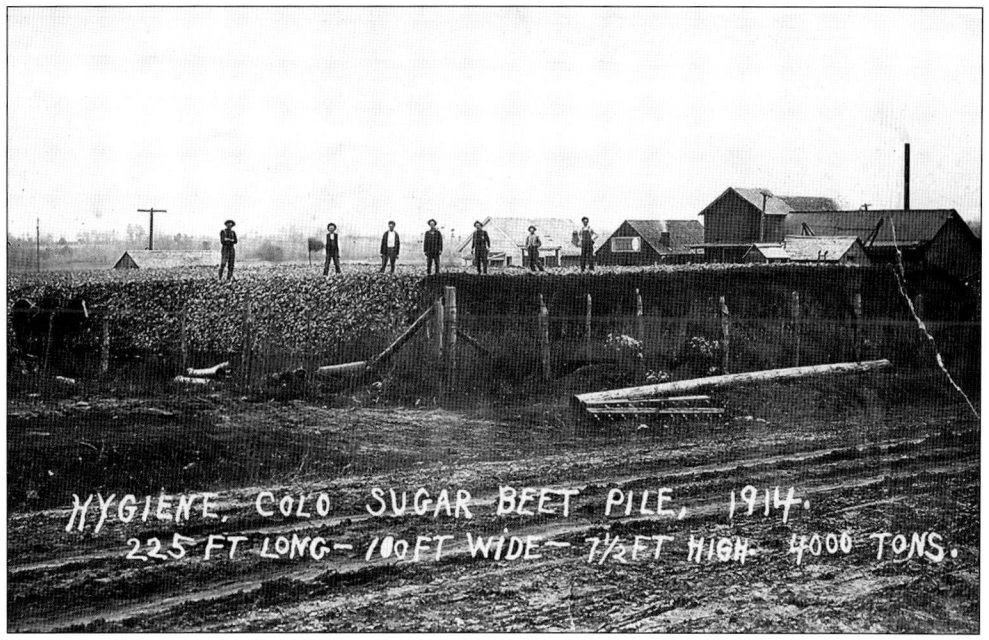

Lignite coal was not produced during summer months; it was not needed and could not be stored without the danger of spontaneous combustion. Miners and others worked in the sugar beet fields around Erie when the mines were closed. This sugar beet pile in Hygiene in 1914 measured 225 feet long, 160 feet wide, 7.5 feet high, and weighed 4,000 tons. (Courtesy CT.)

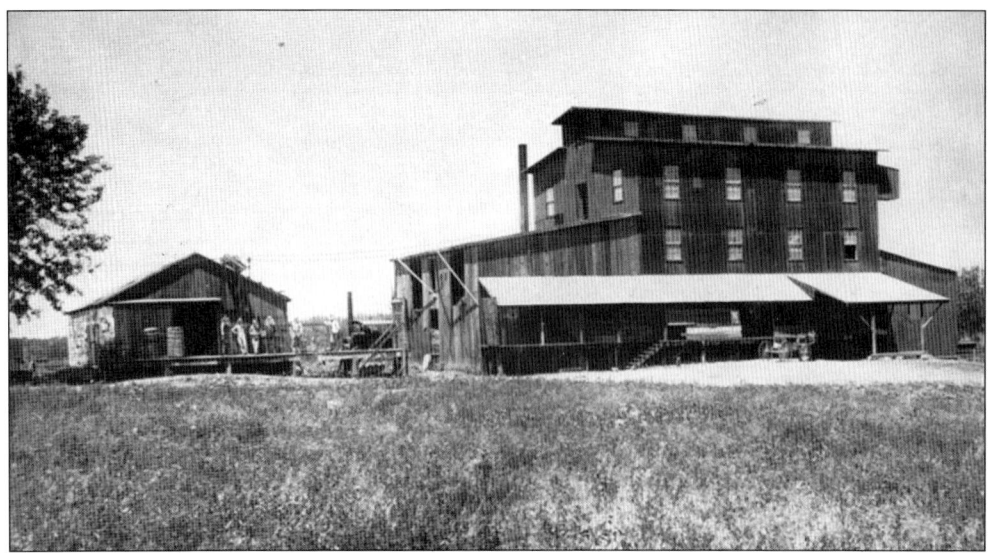

The flour mill at the Wise Homestead was in full operation in the early 1900s. William T. Wise was the president and manager of the mill. It was located on the south side of Wise Road. Farmers would bring their grain to the mill to have it processed into flour for bread and other staples. (Courtesy EHS.)

Grain was placed in sacks at the farms and hauled to the mill. Sacks were hoisted to the top of the mill and emptied into bins where grain was transferred to a hopper dropped below to the mill floor. There it was ground into flour and put back in sacks to be used by farmers or taken to local stores. (Courtesy EHS.)

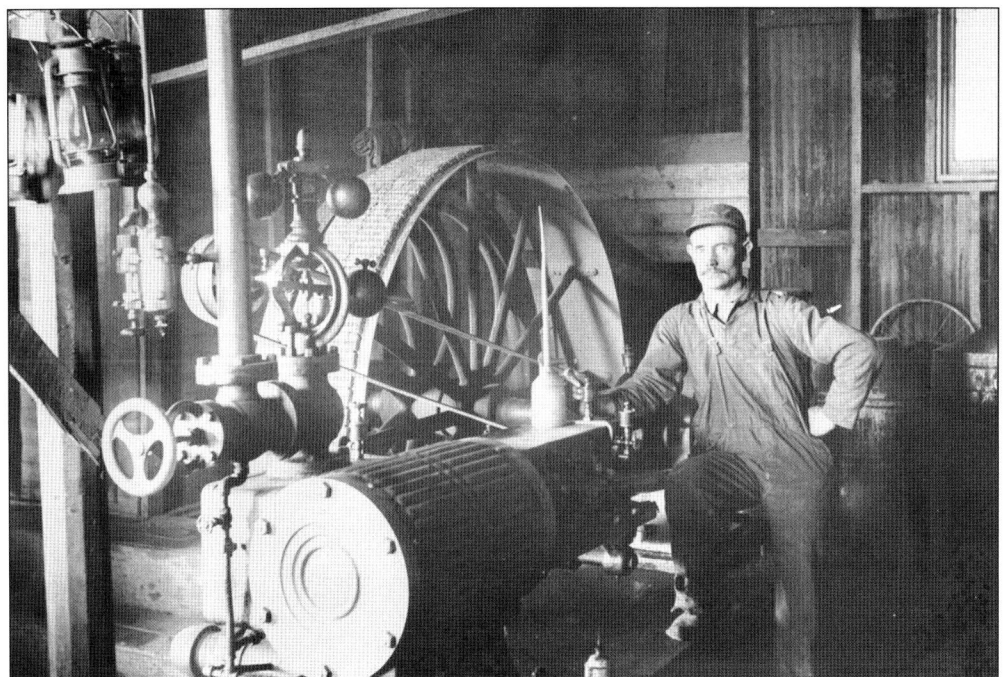

Water or livestock usually powered and turned the series of wheels that converted grain into flour at the earliest flour mills. As technology improved, some older mills were refitted with steel or cast iron turbines that sat horizontally on the floor of the mill. (Courtesy EHS.)

This was a common scene on the Wise Homestead. Buildings were being constructed, demolished, or moved as plans changed about where things belonged. The storage shed next to today's Wise Homestead Museum had been moved years ago from a neighboring property to the north. (Courtesy EHS.)

This photograph shows what looks like J.O.V. and Sarah Wise at Wise Road. With cross-country skis in hand, J.O.V. is traversing the homestead on his way to the flour mill. This method of travel was easier than walking or driving through large snowdrifts. (Courtesy EHS.)

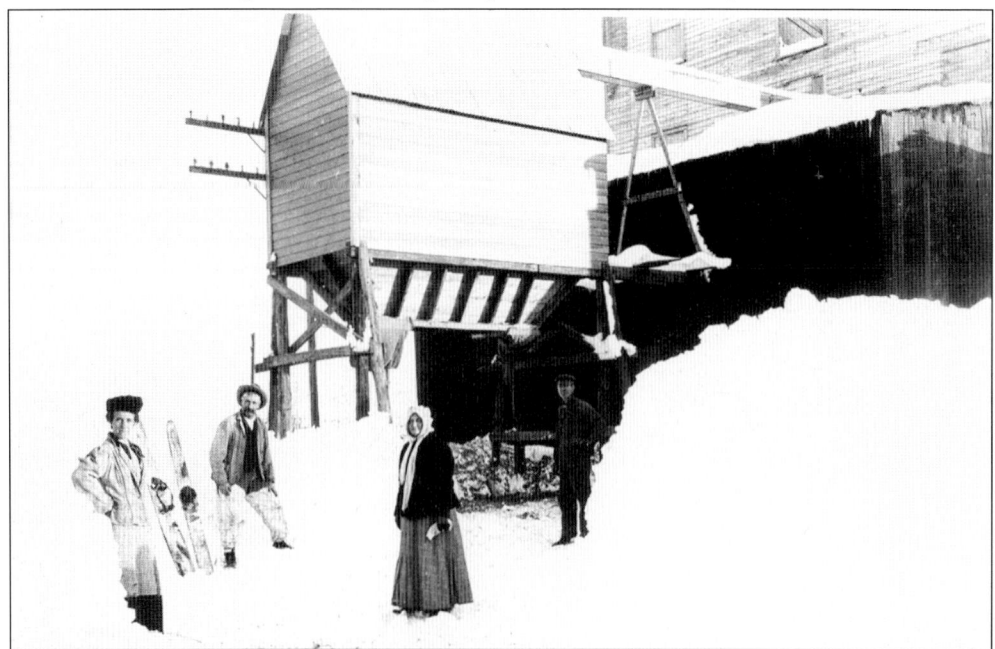

These people stopped for a photograph at the Wise Homestead flour mill in 1916. One person, possibly J.O.V. Wise, is standing next to a pair of snowshoes or cross-country skis. While Erie's snowfalls were typically light, the occasional heavy snowstorm and drifts made it challenging to walk. (Courtesy EHS.)

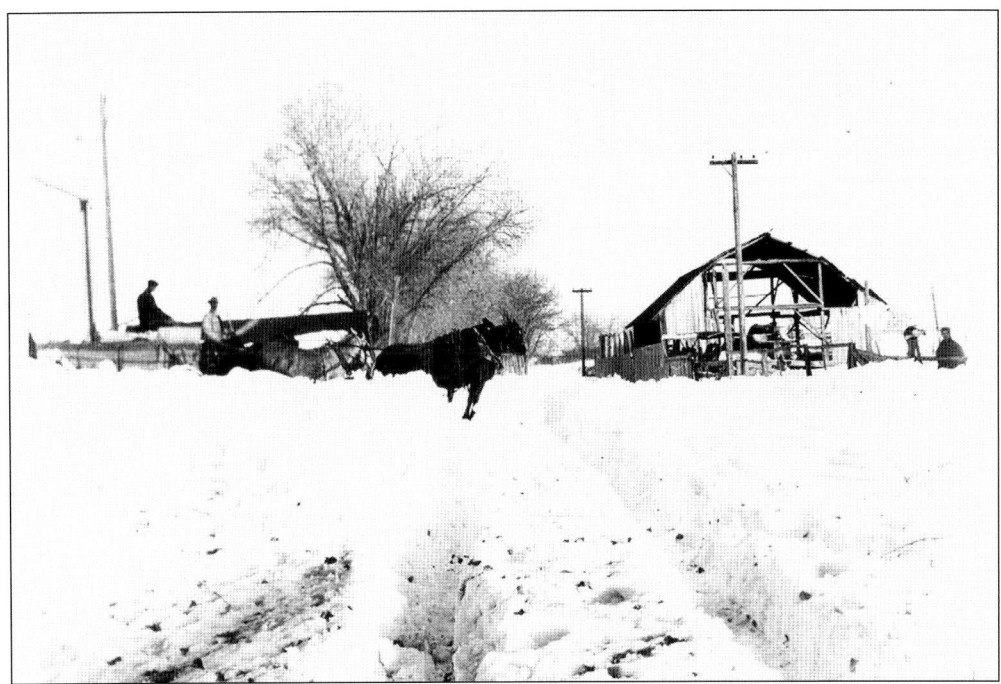

This horse-drawn wagon is crossing snow-covered Wise Road at the site of the Wise Homestead flour mill in 1916. William O. Wise was president and general manager of the mill. Because of a medical condition, he was unable to perform heavy physical labor. (Courtesy EHS.)

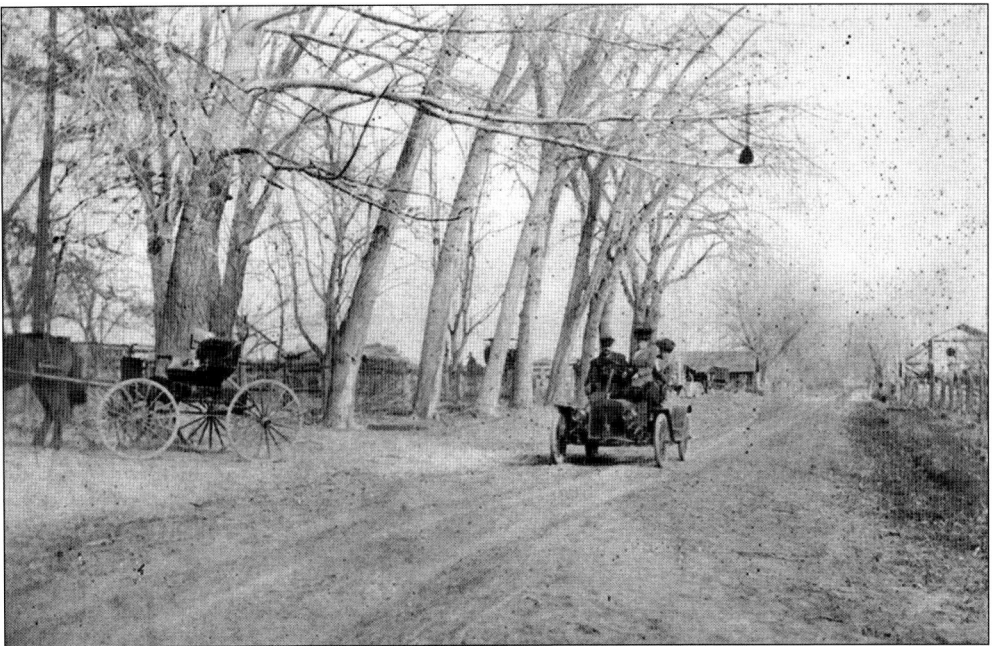

This automobile is being driven west along Wise Road. In the background are the Wise Homestead blacksmith shop on the left and the flour mill on the right. This photograph was likely taken in the early 1900s on what appears to be a fall or winter day with no snow on the ground. (Courtesy EHS.)

Logs were important for a variety of reasons in early Erie. Many were hewn into boards for building, while others were used for support in coal mines. At this time, horse-drawn wagons and sleighs transported logs. It is interesting to note the volume of logs that could be shipped in one load. (Courtesy EHS.)

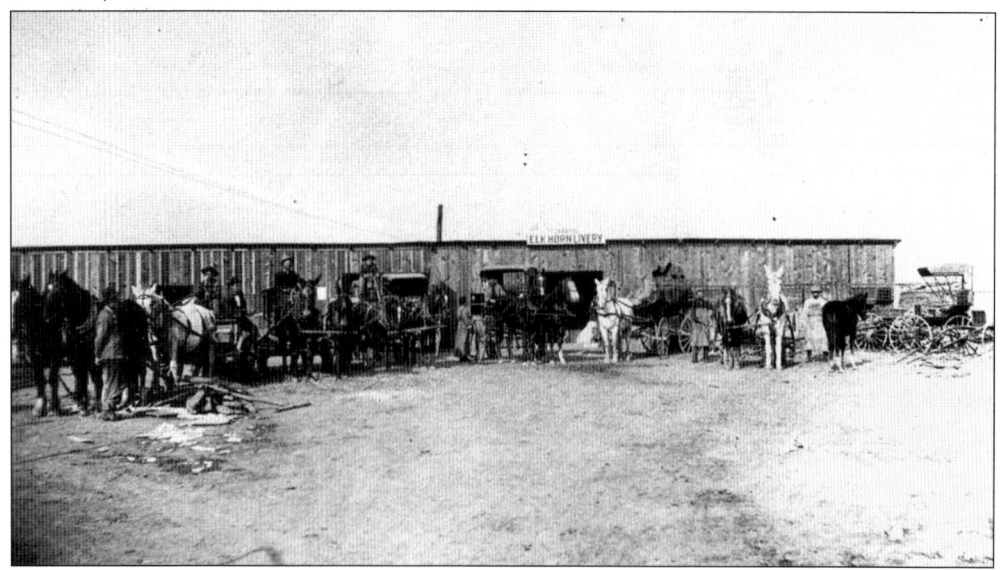

Livery stables were important to those with horses-drawn buggies and wagons in Erie's early development. This seems to be a particularly busy stable. John Marshall, his sons, and a man named Southard operated livery stables in Erie. Blacksmiths and wagon makers were linked closely to the stables. (Courtesy EHS.)

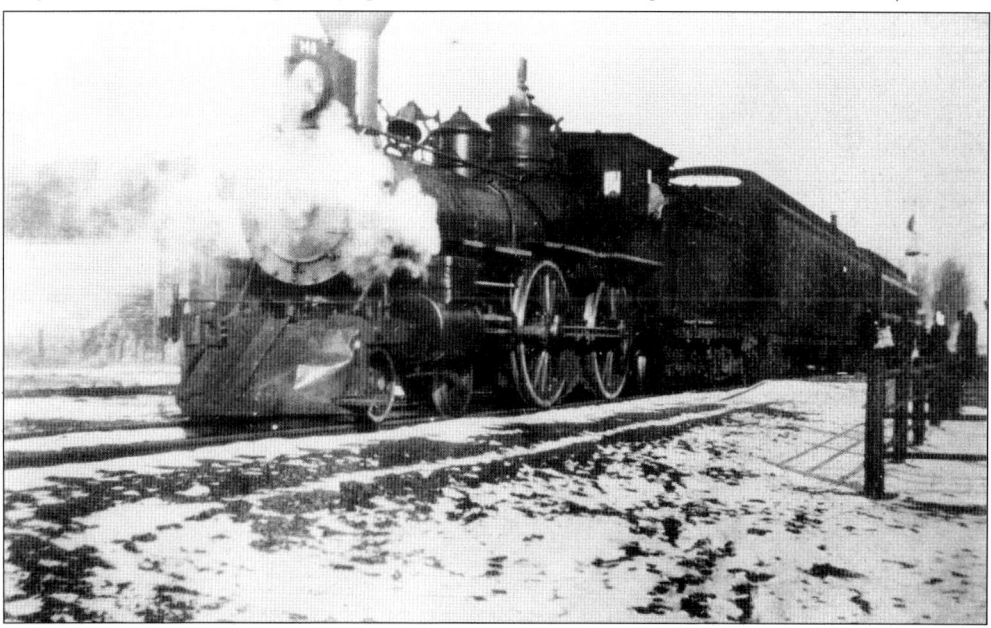

Union Pacific Railroad built a railroad spur from its Denver-to-Cheyenne route into Erie in 1871. Erie needed train service to make mining profitable. The spur connected Hughes Station (now Brighton) with Erie. This photograph shows a train on the ridge east of Erie. (Courtesy EHS.)

This photograph shows one of the train lines serving Erie. By the time the railroads pulled out of Erie in the 1950s, the Chicago, Burlington & Quincy Railroad; Union Pacific; Burlington & Missouri River; Denver Pacific; and Denver & Boulder Valley railroads had established a presence. Even Longmont's narrow-gauge railroad had served Canfield. (Courtesy EHS.)

25

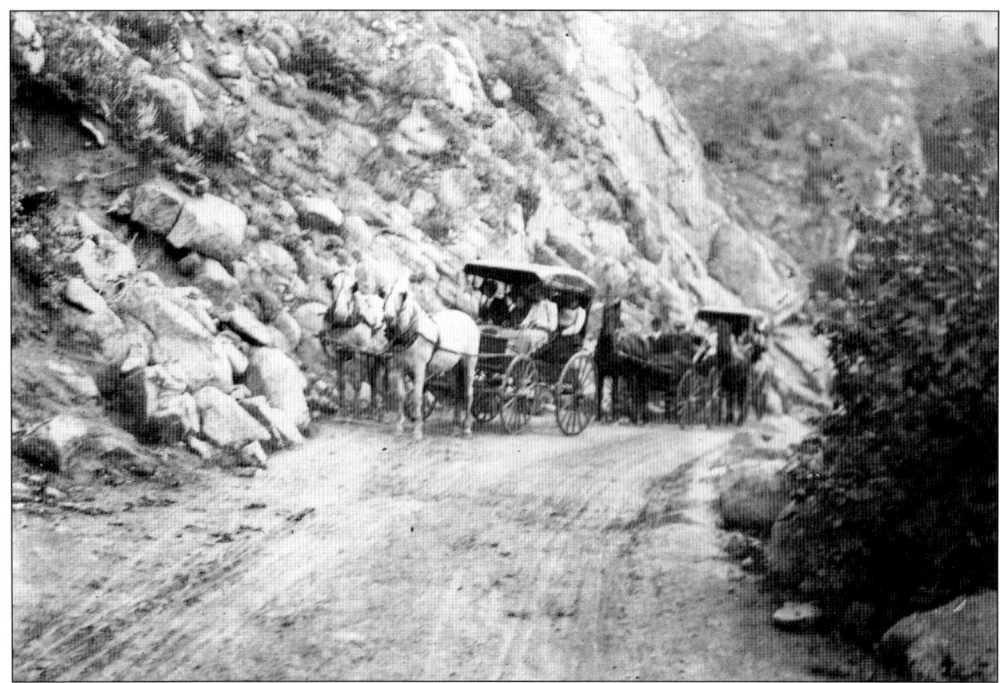

Sometimes, recreation for Erie residents meant getting out of town. These horse-drawn buggies are perhaps shown in the Flatiron Mountains behind Boulder on a morning's ride. Once people were there, they could stay in mountain cabins that were available or turn around and be home by dark. (Courtesy EHS.)

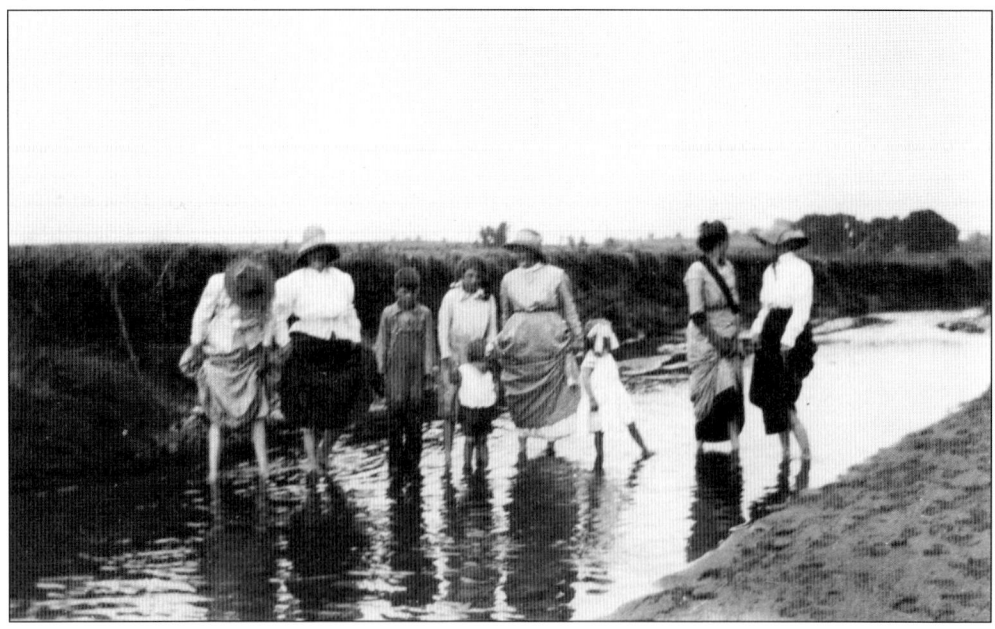

Town folk were able to cool down by splashing in Coal Creek or Boulder Creek, east of town near Canfield. Because gold and silver mining involved the use of chemicals, Coal Creek's water was not fit for consumption. The creek originates in Coal Creek Canyon southwest of Boulder. (Courtesy EHS.)

Two

Pioneers of the Plains

It took a special type of person to cross the prairie to settle a new land, particularly the dry land of northern Colorado. The earliest people in the Erie area were Native Americans, farmers, and merchants. Historians believe they all arrived around the same time. People journeyed through the territory surrounding Erie because of the gold rushes in California in 1849 and at Pikes Peak, Colorado, in 1859. With the passage of the Homestead Act of 1862, more pioneers came to Colorado to claim land and eke out a living.

One of Erie's earliest residents was Jim Baker, a mountain man, fur trader, Indian scout, and militiaman. He was one of Erie's first mine owners. Another was Rev. Richard J. van Valkenburg, a Methodist minister who not only named the town of Erie, but he served Erie as a minister, businessman, trustee, mayor, and Colorado legislator. While not a resident of Erie, Josephine Roche figured prominently in the unionization of the coal-mining industry; she owned controlling interest in the Rocky Mountain Fuel Company.

As the town grew from farming and mining, more people came to operate businesses that provided products and services for the townspeople. Erie residents became involved in various social and fraternal activities. Towns and mines formed baseball teams that would travel to compete with each other. In Erie, baseball teams played on the flood plains along Coal Creek. Games always drew crowds; people would bring picnic lunches. Erie's brass bands would play for events.

Erie was the home of rugged people who turned this dry land into a place to live. They employed technology that was new to the plains, irrigated farms, introduced new crops, and grew trees and gardens where previously nothing grew.

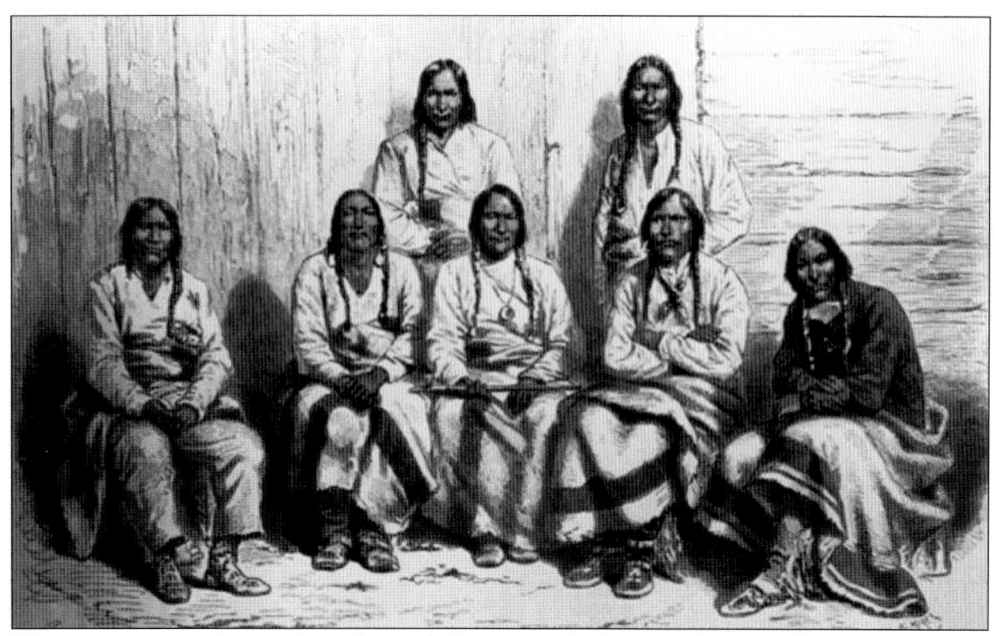

This is a portrait of seven Arapaho and Cheyenne chiefs. Arapaho and Cheyenne used Erie as a winter haven. They traveled together even though they spoke different languages and had separate customs. They migrated from Minnesota to Erie around the same time as the first white settlers. Today, Arapaho and Cheyenne people have relocated to reservations in Wyoming and Oklahoma. (Courtesy NA.)

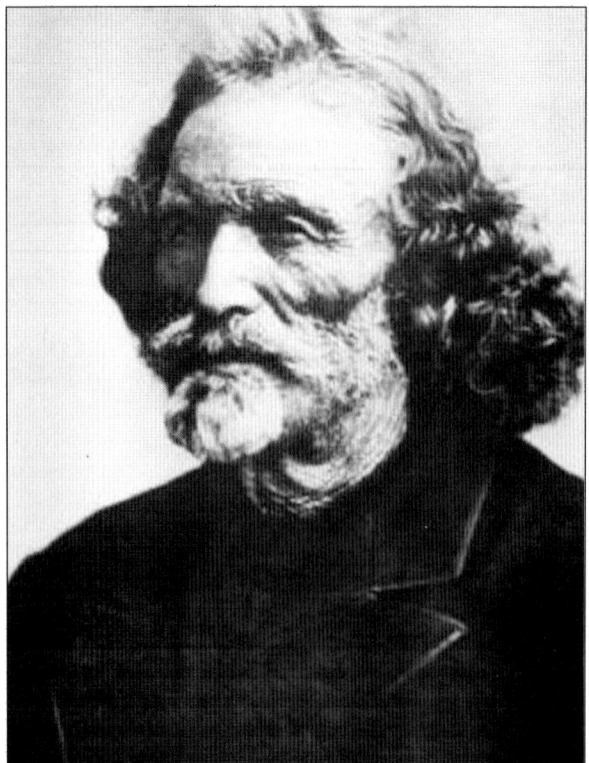

Jim Baker dug what may have been Erie's first coal mine east of town, calling it Baker's Bank. He came to Colorado as a trapper. Fluent in Shoshone and Arapaho sign language, he was a favorite Indian scout for Generals Fremont, Harney, and Custer. He was a captain in the Colorado militia. He was involved in raids against Indians and Mormons. (Courtesy EHS.)

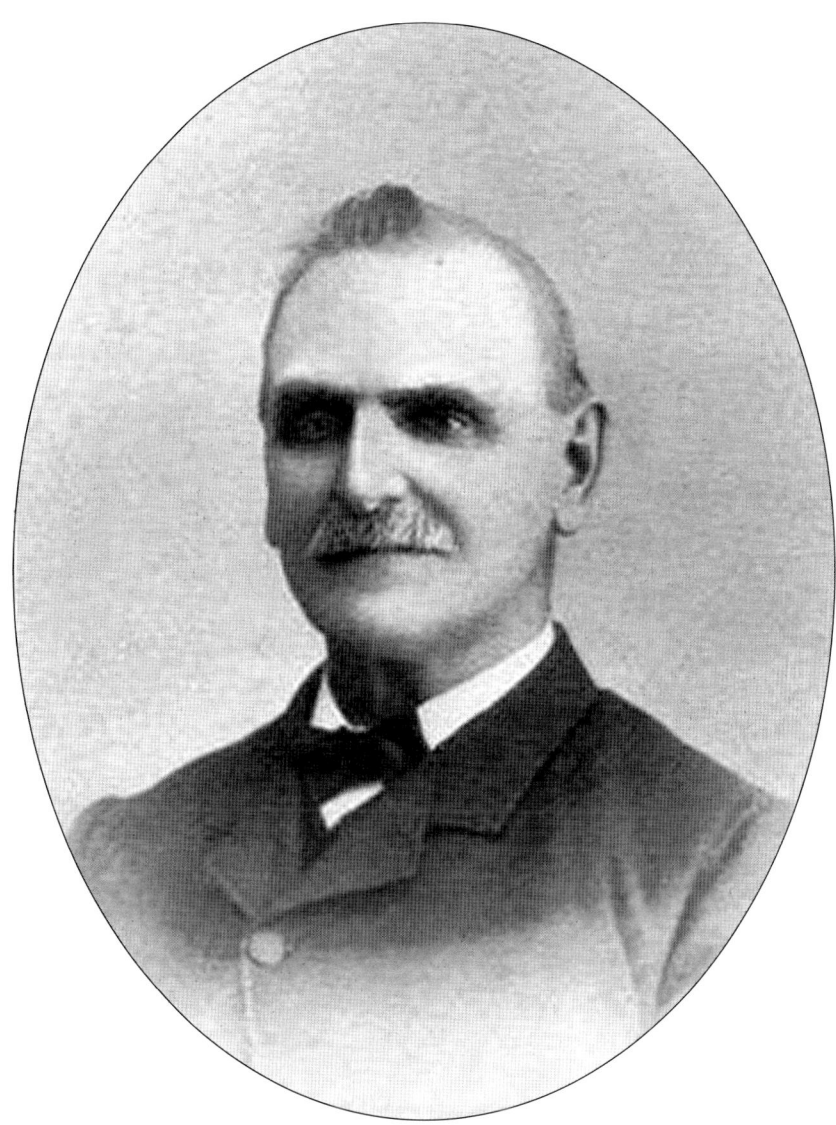

Richard Jeptha van Valkenburg was born in Schoharie County, New York, in 1823. In 1843, he married Cordelia Briggs. During the Civil War, he raised and fought alongside a company of men who served under General Sherman. Once he was ordained a minister, he became a circuit preacher, traveling across the country to spread the gospel. After settling in Erie, he served as Methodist minister, trustee, mayor, and Colorado legislator. He worked in the mines for a short time, owned and operated Erie's first hotel and built Erie's first house. He established Erie's first Protestant churches. Along with officials of the Boulder Valley Mining Company, he helped to establish the town of Erie in 1874. He named Erie after Erie, Pennsylvania, his former residence before heading west. He is considered Erie's town father. He died in 1912 in Fort Collins. (Courtesy EHPB.)

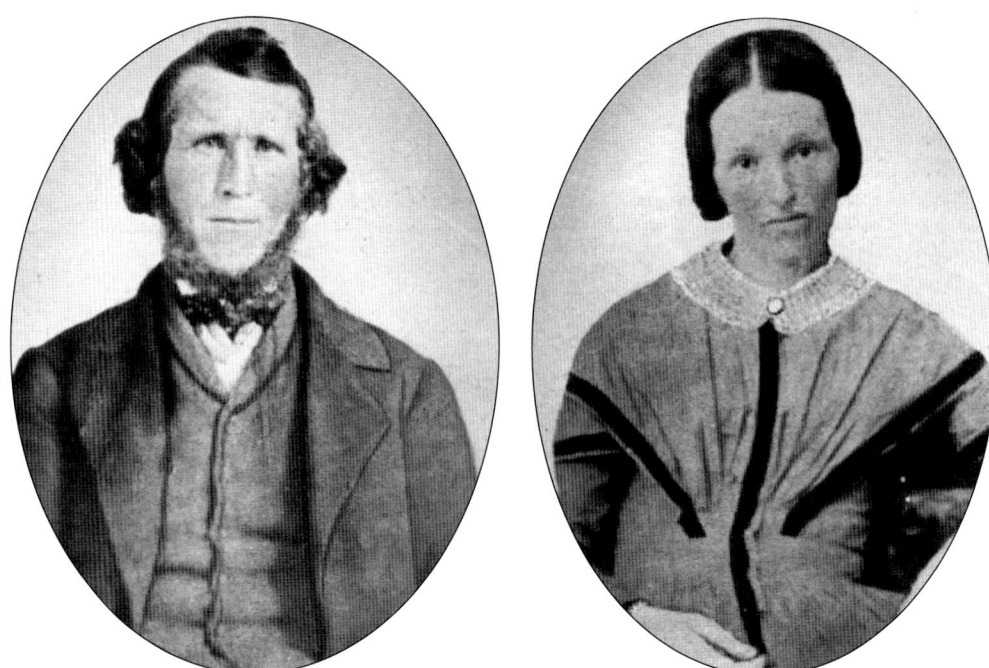

After moving from Wisconsin, Oliver Ellsworth Wise and Adeline B. Wise homesteaded near Erie in 1870. They had three children, William O., J.O.V., and Ada. He built a home that is now the Wise Homestead Museum. He raised wheat, which led to the building of the flour mill on the property. He also raised goats, which he provided for the Greek community in Erie. (Courtesy EHS.)

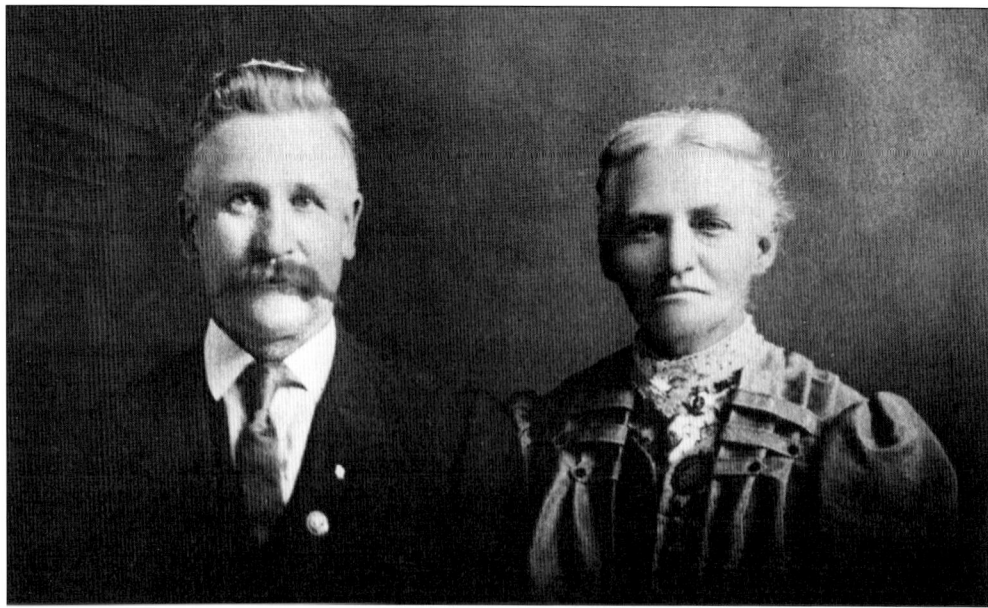

This c. 1910 photograph is of J.O.V. Wise and his wife, Sarah Ann Beasley, daughter of another homesteader family north of Canfield. They had three children. J.O.V. donated the land for the Canfield School, was treasurer of the school district, and planned and helped build local irrigation systems. He and others platted the Canfield area. He was the proprietor of the Standard Coal Company. (Courtesy EHS.)

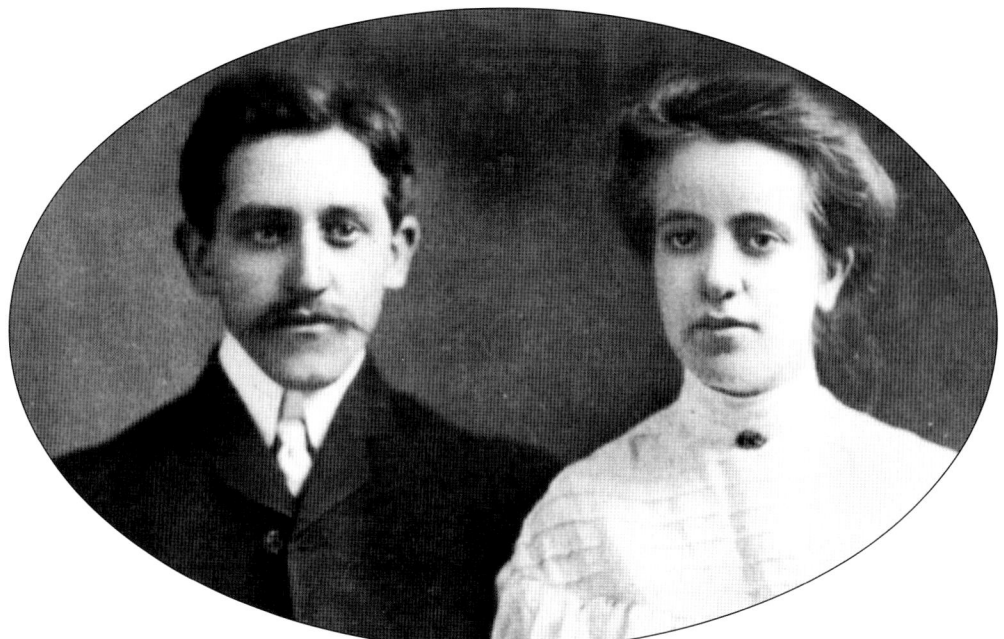

This 1904 photograph is of William T. and Ella T. Wise. William was the son of J.O.V. and Sarah Wise. He served as president and manager of the Wise flour mill in Canfield. William suffered from polio as a child and was unable to perform much physical labor. Farmers from around the area brought grain to William to be ground into flour. (Courtesy EHS.)

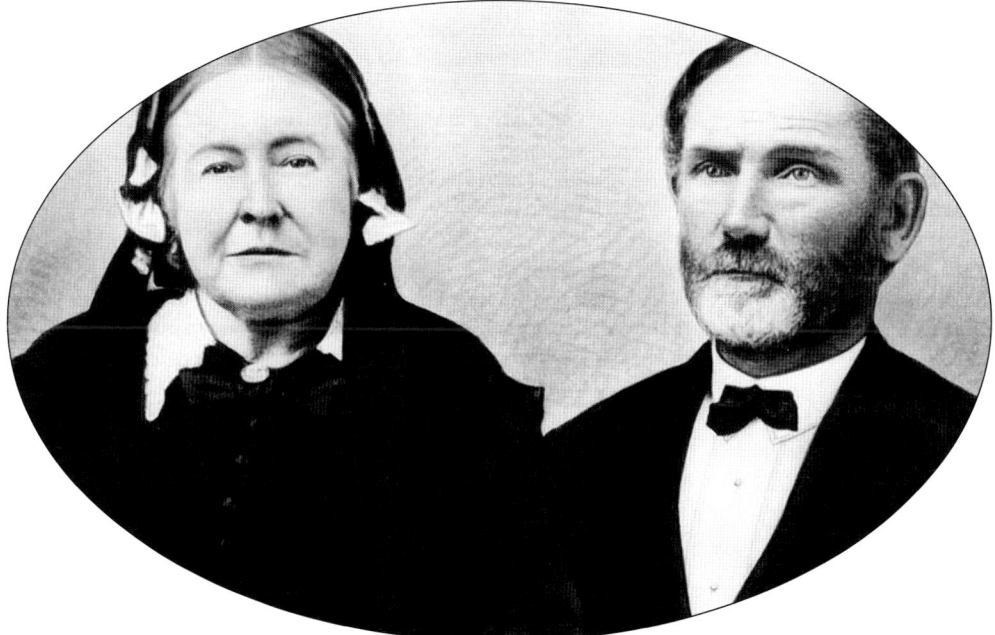

John D. Williams and Mary Phillips Evans were great-great-grandparents of DeWitt Brennan. While DeWitt's place in history is uncertain, he was related to Erie residents Mike Brennan, proprietor of the Star Mine; James Brennan, president of Erie Bank; and Charles Brennan, secretary of agriculture under Pres. Dwight D. Eisenhower. (Courtesy EHS.)

Helen Davis was the first wife of J.D. Williams. While there are no accounts of J.D. Williams in the available records, several Williams family members lived and were buried in Erie. Some held prominent positions. Helen committed suicide later in her life. (Courtesy EHS.)

James L. Wilson was born in March 1858 in Rochester, New York. A brick maker and builder, he constructed many Erie houses and the Methodist church. He formed the J.L. Wilson Fire Hose Company. He married Charlotte "Lottie" Richards in 1887. They had four children. James was mayor of Erie from 1915 to 1921. They resided at 724 Holbrook. (Courtesy EHS.)

John Probert left Wales at 17 to work in America's coal mines. He soon wanted a different career and worked as a salesman in John T. Williams's store. Eventually, he earned his pharmacy license—only the 38th issued by the State of Colorado—and opened Erie's first drugstore. John's wife, Sarah Probert, was one of Erie's first midwives. (Courtesy EHS.)

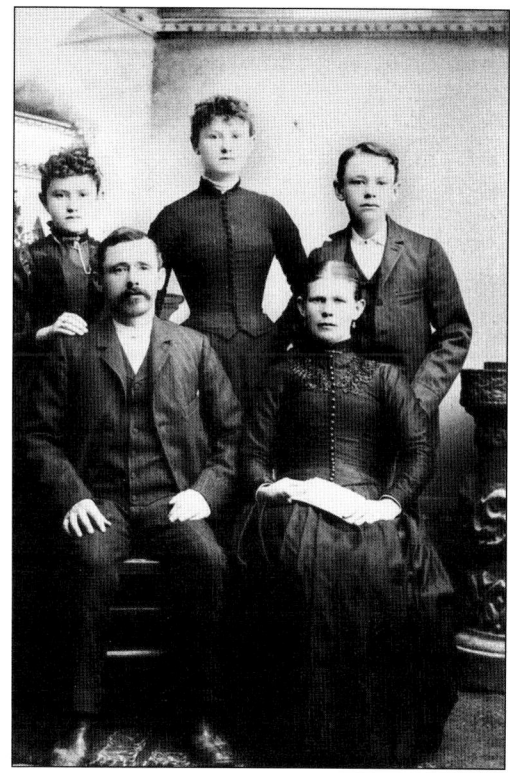

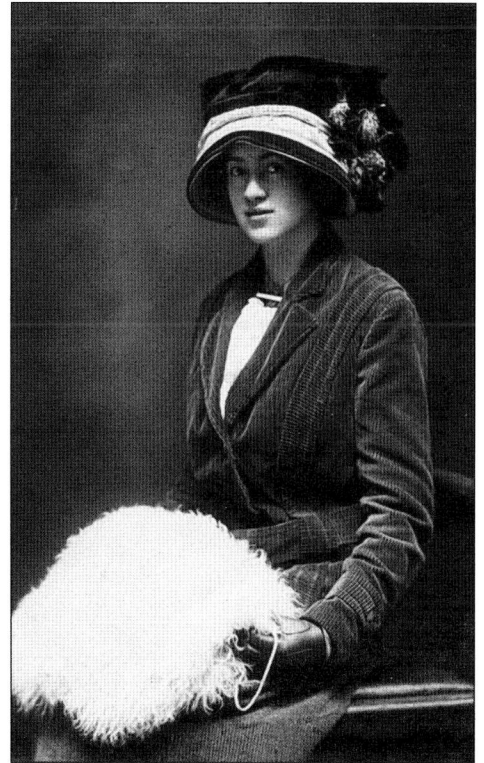

This unidentified Erie woman definitely made a fashion statement. Erie had a variety of stores; she may have purchased her hat from Erie's first milliner, Ella Leyner, who designed, crafted, and trimmed ladies hats. Her purse was also quite fashionable for the day. Early Erie supported clothing stores. (Courtesy EHS.)

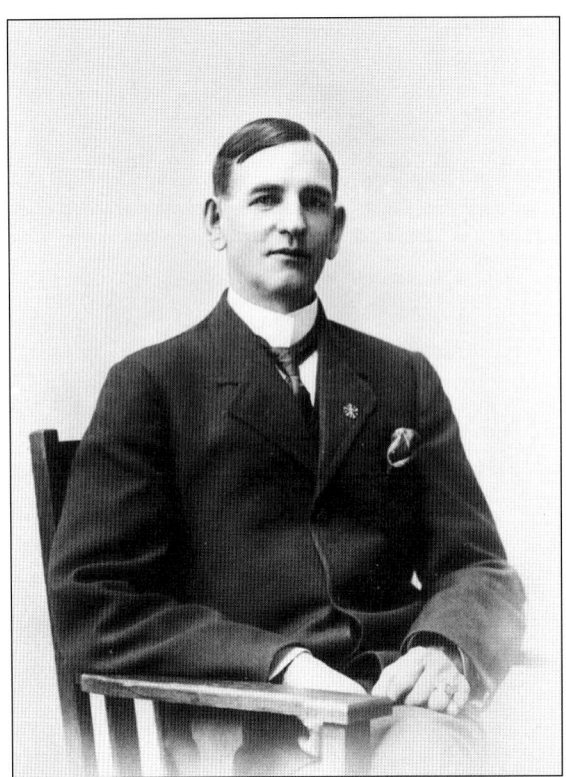

This formal-looking, unidentified man captures men's fashions of early Erie. His high collar and exposed tie were popular in the late 1800s and early 1900s. His slicked-down hair on top with hair cut close and high around the ears suggest a bowl cut. Notice that he is sporting a pin on his lapel, perhaps identifying him as a member of a fraternal organization. (Courtesy EHS.)

While this gentleman may look like Paul Newman in *Butch Cassidy and the Sundance Kid*, he is actually B.C. "Bud" Pitchford. Bud was Erie's constable and Erie's only maintenance man. He lit the streetlights each evening, graded the streets during the summer, and removed snow and ice from them in the winter. (Courtesy EHS.)

Bud Pitchford is pictured here resting beside a furnace where he has been shoveling coal. He would heat the town hall and other buildings as part of his duties as maintenance man. When he heard of disruptions from striking miners in nearby towns, he would turn out the streetlamps in the evening to discourage dissidents from overflowing into Erie. (Courtesy EHS.)

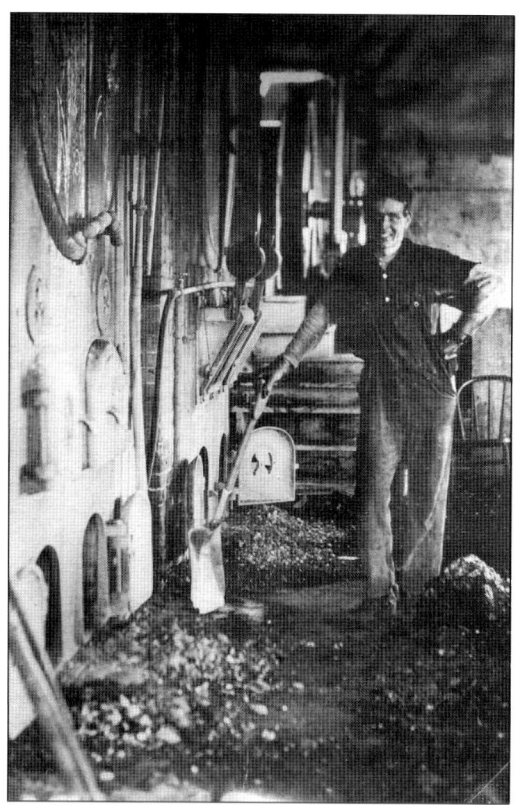

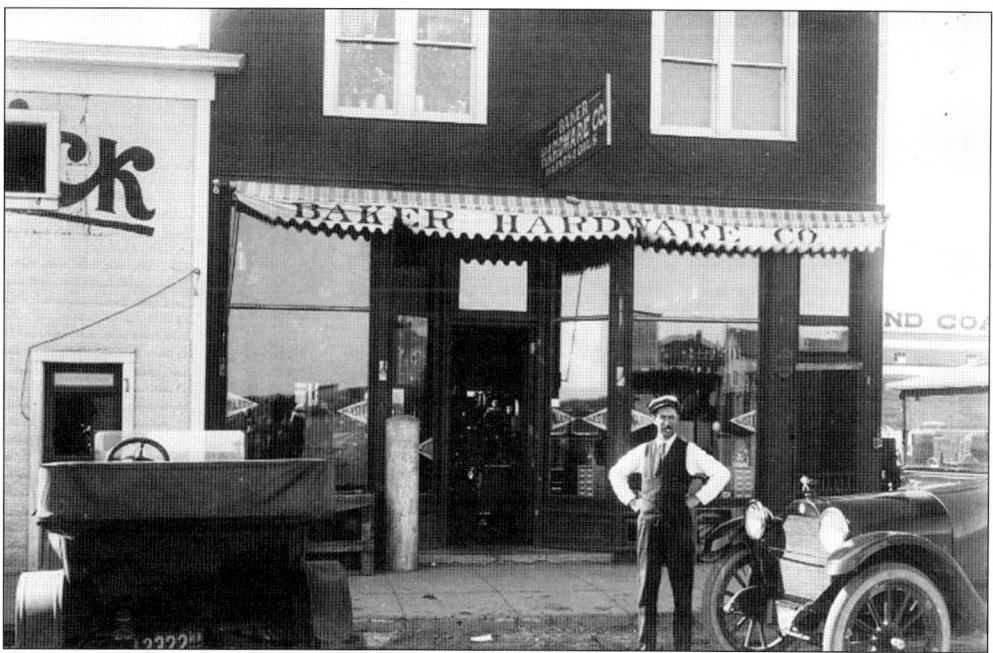

This early-1900s photograph shows Paul Collet posing in front of Baker Hardware next to a Studebaker with artillery rims. Paul co-owned and operated the garage, with the Buick sign, next to the hardware store. His business partners were Bill Krukeburg and Fritz Carmichael. (Courtesy EHS.)

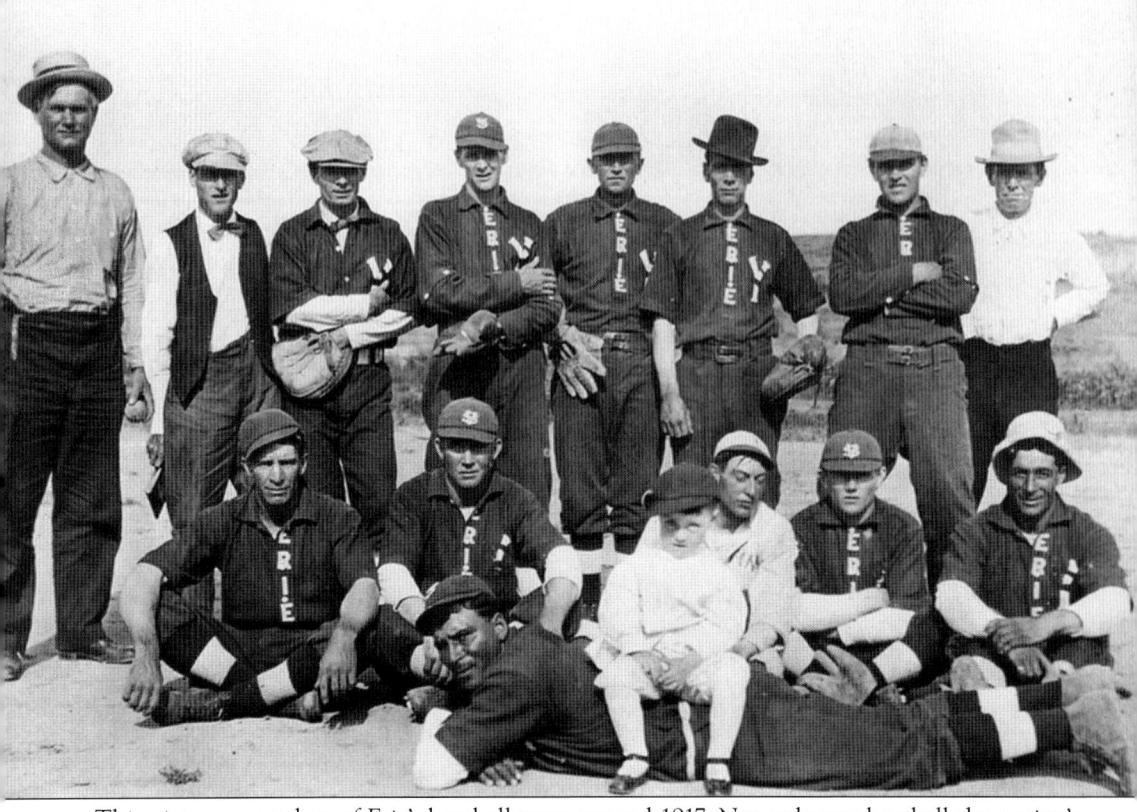

This picture was taken of Erie's baseball team around 1917. Not only was baseball the nation's pastime, but it was also Erie's. Teams would gather to play along Erie's flood plain near Coal Creek. Teams from other towns or mining camps would travel to play against Erie's team. Families would pack picnic lunches and make their way to the field. Erie's brass bands would show up to entertain the townspeople at these festive events. Just like the big league teams, the local teams donned their own uniforms, answered to team managers, and selected batboys and mascots. The players were miners and merchants when they were not playing ball. Children also played a form of baseball, using old broomsticks and wadded-up socks. (Courtesy EHS.)

Canfield formed a baseball team to compete with other local teams. For the Canfield team to play at Erie, it had to travel from where Jasper Road and 119th Street are today. Canfield's team was made up of miners, farmers, and mill workers. This photograph suggests that teams may have tried to outshine other teams with their uniforms. (Courtesy EHS.)

The Puritan Mine and Camp were located where Interstate 25 and Colorado 52 intersect today. Puritan formed its own baseball team to compete with other local teams. Here, the team poses in front of a local store. Notice the sign in the window that announces the baseball game and the dance at Jarosa. Jarosa was the site of dances that went on all night. (Courtesy EHS.)

William Whiles came to Erie from England. He worked 10-hour days in his aunt and uncle's Garfield Mine; he spent evenings studying stationary engineering and became a hoist engineer for the mine. He eventually co-owned the mine with William H. Drinkwater. In 1903, he left mining to work for the Erie Bank as a teller; he eventually became president. This photograph was taken in 1911. (Courtesy EHS.)

This photograph shows James Brennan behind the teller cage at Erie Bank. Brennan became president of the bank. Erie bank was well run and continued to operate when Pres. Franklin D. Roosevelt ordered a national bank holiday in 1932 because it had sufficient assets. Many banks were unable to reopen following the holiday. (Courtesy EHS.)

William Henry Drinkwater was born in England in 1858. His wife, Harriet, was born in 1855. After moving to Erie, William eventually became co-owner of the Garfield Mine with William Whiles. They are shown here with their three children. Harriet died in 1929, and William died in 1933. (Courtesy EHS.)

This is the Wilson family posing in front of the family home. Lottie Wilson is seated, and her four children are dressed up for the picture. James Wilson was a brick maker and home builder. Notice the brick work on the front of the building. Not many homes in the area had that touch. (Courtesy EHS.)

Charles Elzi was born in Boulder in 1890. He came to Erie in 1912, directly from Denver, to open a drugstore. He had earned his pharmacy degree from Capitol College. His drugstore had a soda fountain with a mirrored back bar. It was one of the earliest licensed drugstores in Colorado and one of the first to dispense insulin. He married Doris Wilby in 1917, and they had four children, William, Charles, Betty, and George. Doris was a teacher in Erie. Elzi served as mayor during the 1940s. He was also an active charter member of the Lions Club; people say he never missed a meeting. He was also president of the Erie Bank. Charles died in 1972 and is remembered as being helpful and friendly to the community. (Both courtesy EHS.)

Charles Elzi posed here for a photograph inside his pharmacy at 502 Briggs Street. This building was originally constructed in 1892 and served as Winslow Smith's drugstore. Charles worked in this store before eventually opening his own drugstore. This photograph shows Charles obviously further along in his career. Notice the soda fountain and stools. (Courtesy EHS.)

This group of men stopped to be photographed at Mike Brennan's pool hall and saloon. Noteworthy are the bar, wall covering in the rear, wooden floors, free-standing stove, and wooden chairs. The men are all dressed respectfully. Someone brought a small child into the establishment. (Courtesy EHS.)

These two girls—likely Clarence Bixler's daughters—are picking flowers in the Bixler yard at 485 Holbrook Street. Clarence came to Erie in 1909 to open a medical practice after graduating from the University of Colorado at Boulder. He attended to many of the miners who were injured or killed at the Columbine Mine massacre in 1927. He introduced penicillin and x-ray machines to Boulder County. (Courtesy EHS.)

The Morgan family posed for this picture in their yard on Main Street. John S. Morgan came to Erie from Pennsylvania. He was Erie's postmaster and a merchant. He opened his first store with his brother but bought him out and moved his store to the space below the International Order of Odd Fellows lodge on Briggs Street in 1897. (Courtesy EHS.)

Erie's first fire hose brigade was started by J.L. Wilson, the town's brick maker and builder. This grainy photograph was most likely taken on Wells Street in front of Erie's first town hall, which housed the fire station. The fire hose was connected to a two-wheeled cart that the firefighters pushed to fires, where they had to unfold the hose and hook it up to one of Erie's few fire hydrants. (Courtesy EHS.)

In 1935, Erie's fire hose brigade competed in Loveland at the Colorado State Fireman Convention. By now, the team was using fire trucks to deal with fires, but one competition, which still exists today among firefighters, is to see how quickly teams can unfold and lay out their hoses with no kinks or other obstructions. (Courtesy EHS.)

This is a gathering of members of the Independent Order of Odd Fellows and its women's auxiliary, the Rebekahs. The IOOF was founded first on religious principles and then on its three-link values of friendship, love, and truth. The meeting hall was above the corner store on Briggs and Moffat Streets. (Courtesy EHS.)

This shows a gathering of the Rebekah Assembly on Moffat Street below the IOOF hall at 500 Briggs Street. The Rebekahs were a benevolent society of women dedicated to helping the elderly, children, orphans, and other less-fortunate people. They operated from a religious foundation. Today, the Rebekah Assembly includes men. (Courtesy EHS.)

An Act of Congress established the Knights of Pythias in Washington, DC, in 1864. This international, nonsectarian order is founded on the belief of a supreme being and is dedicated to universal peace through understanding of all people. Erie's chapter and its women's auxiliary, the Pythian Sisters, were formed early in Erie's history. (Courtesy EHS.)

This photograph was taken in 1910 of the Ladies of the Maccabees of the World. This organization's purpose was to provide support in the form of insurance for widows and their families and for those who were injured. The organization was exclusive; its membership was limited to white women, and its insurance did not cover coal miners and others involved in dangerous professions. (Courtesy EHS.)

45

The Red Cross was started in the United States by Clara Barton in 1881. The uniforms at that time looked more like a nun's habit. The red cross comes from the Swiss, who inspired the Red Cross movement. This photograph shows some of Erie's volunteers, five of whom have been identified by last names and in no particular order: Drinkwater, Elzi, Brennan, Wilson, and Foreman. (Courtesy EHS.)

Another organization that formed in Erie was called the Preparing for Marriage Club (PFM). By the age of the members in this photograph, one might guess that this is a reunion of some of the club's early members. Similar organizations today encourage older couples to counsel those who are engaged to be married. (Courtesy EHS.)

46

This 1899 photograph shows parishioners gathered for the dedication of St. Scholastica's Catholic Church. The church is believed to have been completed in 1898. Benedictine priests brought Catholicism to Erie, and early worshipers relied on circuit priests to hold services. (Courtesy EHS.)

People posed for a photograph while waiting for train service at Erie's train stop. Erie's first train stop was built by Union Pacific and located east of town across Coal Creek; people had to cross the creek on Palmer Street. Some accounts report the construction of other train stations, one just south of town and another west of town on High Street. (Courtesy EHS.)

Many of Erie's settlers brought musical talents with them. As people discovered others with similar interests, they formed bands. Some were called concert bands, while others were identified as brass bands or marching bands. As this photograph shows, most of the musicians played brass instruments or drums. (Courtesy EHS.)

Erie's brass bands played at picnics, baseball games, concerts, and other town events. The town was known for celebrating national holidays and its own holidays related to mining and celebrating union leaders who helped establish workers' rights. Brass bands were a great form of entertainment. (Courtesy EHS.)

Some of the musicians in the town's early brass bands were merchants and town leaders. Still, many band members were miners who claimed they enjoyed playing in the bands because, particularly for the horn players, blowing into their instruments made them feel as though they were clearing their lungs of the powders and gases from the mines. (Courtesy EHS.)

The size of the bands varied. This band had more musicians than some of the other bands. Based on the background, the band posed in front of a brick building on a tree-lined street in a residential neighborhood. Notice the way people were dressed and their facial hair; this photograph likely dates to the late 1800s. (Courtesy EHS.)

This unidentified Erie woman stopped to be photographed near the corner of Briggs and Wells Streets with Erie's first town hall in the background. The red-dirt streets and wooden building were characteristic of the time. Next to town hall, one can make out the side of J.T. Richards's store. (Courtesy EHS.)

Sarah Beasley Wise posed here for a photograph, probably in her yard. Sarah was the daughter of one of the area's early homesteaders who lived north of the Wise Homestead toward Longmont. She met and married J.O.V. Wise, son of another early homesteader. Notice the wicker-type chair, blanket, and the top she is wearing. (Courtesy EHS.)

This late 1800s or early 1900s photograph shows a large section of what appears to be the lower grades at Erie's first school on Briggs and Wells Streets. Notice the clothing worn by many of the boys: caps, jackets, knickers, boots. The girls seem to be wearing similar dresses, suggesting many may have been purchased at the same local store or were homemade. (Courtesy EHS.)

This unidentified couple looks like they should be starring in a silent movie titled *I Only Have Eyes for You*. The pose seems inappropriate for the era, with the lady practically sitting on the man's lap. Notice the clothing each is wearing—her with beads, him with a high-collared jacket. Their hairstyles also fit the times. (Courtesy EHS.)

William and Sarah Bailey and their three children posed in front of the family automobile on one of Erie's residential streets. A trip to Erie's Mount Pleasant Cemetery will lead to a large headstone with the Bailey name. William was born in 1854 and died in 1927; Sarah was born in 1846 and died in 1927. (Courtesy EHS.)

This photograph was taken at the home of J.O.V. Wise. In the passenger seat of the automobile is Sarah Beasley Wise. J.O.V. is in the driver's seat. Standing alongside the automobile is Ella T. Wise. The remaining people are unidentified. (Courtesy EHS.)

J.O.V. Wise is near a bridge in Wisconsin after a muddy road trip. In the passenger seat is Sarah Beasley Wise. They proudly display a University of Colorado pennant with the dates 1870 and 1915. A good guess is that this picture was taken around 1915 and that they were most likely driving to a football game. (Courtesy EHS.)

An unidentified couple stopped to be photographed while touring in their open-air car. The white picket fence and the lush vegetation make this picture even more attractive. (Courtesy EHS.)

53

This glary photograph shows the Wise family having an outdoor meal at the Wise Homestead. In the foreground on either end are J.O.V. Wise and Sarah Beasley Wise. And those standing opposite of each other from across the table are most likely William T. and Ella T. Wise. (Courtesy EHS.)

A young child is playing in the yard next to the house at the Wise Homestead. Notice in the background the brickwork that is not part of the original house. The house has been restored as the Wise Historical Museum, and the brickwork is no longer visible. (Courtesy EHS.)

Wise family members and their dog pose in front of the brick house that was built on the homestead, just west of the original house. The house has since been sold to the Voltz family, but J.O.V. and Sarah Beasley Wise likely used to own it. The young woman with the long blonde hair is Sarah A. Wise of the Erie Historical Society. (Courtesy EHS.)

Joe C. Jaramillo was an Erie resident who worked in the Monarch Mine in Broomfield. In 1936, there was an explosion at the mine that killed eight miners, including Jaramillo. Jaramillo's body was never found, and a monument to him was erected beside US Highway 36. Today, after relocation, it is in John Varra Park, next to Flatirons Crossing mall. Jaramillo's name appears on the Miner Memorial in Erie. (Courtesy PS.)

Bill Grimson is threshing a wheat field on another Erie resident's property. The Grimson name shows up on two gravestones in Erie's Mount Pleasant Cemetery, but neither is Bill or William. Grimson also shows up as an owner of a home on Holbrook Street, but again, records are incomplete as to the first name. (Courtesy EHS.)

When Jules Regnier was not working as a miner at the State Mine or on the National Fuel Company First Aid Team, he was often working for other residents on their farms. Here, Regnier is tilling the land behind horses at the Burke property on Arapahoe Road. (Courtesy EHS.)

An Erie man and woman are working in the field bagging wheat to be taken to the mill. For the era, this wagon seems to be sophisticated in that it has apparatuses to help load the grain into the wagon, shoot the grain into piles, and drop the grain through a chute into the waiting sacks. (Courtesy EHS.)

This unidentified young couple posed for a photograph with their tractor and cart. It is difficult to tell what they are harvesting. The wagon behind the tractor and cart may have sugar beets in it. The tractor's wheels are metal, with cleats on the rear wheels for traction. (Courtesy EHS.)

Men posed atop farm machinery and wheat stacks. When the wheat was harvested, it then had to be threshed, separating the wheat from the chaff. Then, the wheat was stuffed into sacks, stored in silos, and finally taken to a mill to be turned into flour. (Courtesy EHS.)

This unidentified man and boy seem to be unloading hay from a wagon for cattle feed. Notice the cow in the foreground near the boy. Since livestock and horses were so plentiful in early Erie, hay was another profitable crop for local farmers. (Courtesy EHS.)

Farmers are standing atop what appears to be sugar beets. Wagon loads of beets were taken to where they could be processed into sugar. German farmers brought this technology to the prairie states, where people previously relied on more expensive sugar from sugar cane–producing climates. (Courtesy EHS.)

Anthony Mosnik, son of Anton and Anna, was born in 1897 and died in 1974. Rose Jordan Mosnik was born in 1902 and died in 1965. "Tony" is listed in the Erie Miners Memorial in front of town hall. Other family names related to them through marriages were Gorce and Waneka, well known to Erie historians. (Courtesy CWD.)

59

Anton Mosnik was born in 1864 and died in 1932. Listed as his wife on the family genealogical chart is Anna Getrinika. This picture shows Flora Mosnik. An Alvin Mosnik shows up in Erie's records. He served in the US Army during World War II and married a woman in England named Ruth who joined him in Erie in 1946. (Courtesy CWD.)

Mary Rodich Jordan and Joseph Jordan were the parents of Rose Jordan Mosnik. Their birth and death dates are not listed. Current Erie resident Colleen Waneka Dame is a descendant of the Mosnik and Waneka families. (Courtesy CWD.)

Ned Wilson and Jean Larson posed for this picture inside their Wilson-Larson Store. The store was located at 500 Briggs Street. Of interest are the apparent cleanliness and organization of the store, the merchandise, and Ned and Jean's attire. They are both shown wearing smocks, and Ned also has on a shirt and tie. (Courtesy EHS.)

Two men pose for a photograph in what appears to be a kitchen appliance store. Notice the old stoves and shelves full of pans and other merchandise. Ceilings like the one shown are commonly found in buildings from the late 1800s to early 1900s, inspired by the Victorian era. The coal- or wood-burning stove was used for heat. (Courtesy EHS.)

61

This photograph is inside Probert's Drugstore. John Probert is dressed in typical style for the day with a white shirt, bow tie, slacks, and dress shoes. On the shelves are Bishops Biscuits, a favorite snack imported for Erie's immigrants from Great Britain. Up high on the back shelf are boxes of Kellogg's Corn Flakes, Aunt Jemima Pancake Mix, and H-O Oats. (Courtesy EHS.)

An unidentified man poses in this drugstore that doubled as a variety store. Some of the signs suggest remedies for various ailments. The bottles on the shelves are likely liniments or tonics; although, they could be mistaken for liquor bottles. Erie was the only wet town within miles. (Courtesy EHS.)

This is the fourth-grade class at Lincoln Elementary School in 1932. Miss Twiggs and Mabel Erickson taught 53 students. The class roster reads like a who's who of well-known Erie family names: Harold Wiggett, Billie Brack, Earl Bailey, Johnnie Brennan, Norwood and Billie Lawley, Alvin Mosnik, Joe Koss, Lloyd Miller, Charlotte Morrison, Margaret Abeyta, Maudie Sherratt, Winifred Bracegirdle, Lucille Hefftner, and Nettie McAfee. One thing that Erie historians mention frequently is the diversity in the town. This picture, with its roster, shows a great deal of diversity from European countries and some from Spanish-speaking countries. The children's clothing styles changed dramatically from those of the late 1800s and early 1900s. Considering the nation was in the middle of a depression, the students appear well dressed. (Courtesy CWD.)

A teacher and her students posed for a photograph alongside Erie's first dedicated school at the southeast corner of Briggs and Wells Streets, the site of today's post office. This school was built in 1881 and accommodated around 100 students. (Courtesy EHS.)

These students posed on the porch of Erie's first schoolhouse. Notice the varied clothing styles: the boys wear overalls or coats and bow ties, and the girls seem to have come to school this day knowing they would be photographed. (Courtesy EHS.)

This photograph shows the certificate of Bud Pitchford, indicating he was a member of James L. Wilson's Fire Hose Company for five years. Bud was Erie's first constable and maintenance man. Wilson was a home builder who also built Erie's Methodist Church. The document was notarized by James Brennan, President of Erie Bank. (Courtesy EHS.)

This photograph shows the pharmacy license of John Probert. He was the 38th person to be a registered pharmacist in the State of Colorado. After leaving Wales at the age of 17, he worked in Erie's mines for a while. Probert soon realized he wanted to do something else. He opened the first licensed pharmacy in Erie. (Courtesy EHS.)

Female students at Erie High School appear to be conducting experiments in a chemistry class. Notice the protective sleeves and aprons. Most of the girls pinned up their hair up as a precautionary measure. (Courtesy EHS.)

Female students at Erie High School are preparing food in a cooking class. Notice the stove at the rear of the classroom. On the back table, it appears that students are cooking over a griddle. Notice what may be an electrical outlet and cord in front of the table. (Courtesy EHS.)

These elementary school students seem to be dressed for a special event or a play. Their clothing is nothing like what typical children wore in Erie. From the leaves on the ground, a good guess would be that this photograph was taken in the fall. (Courtesy EHS.)

This group of students is dressed for a theatrical performance. It appears they range from middle- to-high school age. The photograph seems to have been taken at someone's farm, where the setting might better match the costumes. (Courtesy EHS.)

It is difficult to determine from the costumes and backdrop which play this group of Lincoln School students was performing. The stage was framed in brick, which was characteristic of the outside and much of the inside of the school. (Courtesy EHS.)

This group of primary-grade students is being taught to parse sentences, according to what is written on the chalkboard. Notice the radiator on the back wall, the piano on the left, and the type of divided table with cubby holes. (Courtesy EHS.)

These students are dressed well for school. Did they dress this way for the picture or were they expected to dress this way every day? This appears to be a classroom used to study world cultures, based on the flags on the wall. It would be interesting to determine how many of those countries still exist today. (Courtesy EHS.)

This is a very crowded classroom at the Canfield School. A close look at the poster on the wall indicates this picture was taken in 1926 around Easter time. The piano blocking the doorway suggests there may have been no surprise visits by the fire marshal. (Courtesy EHS.)

These pals pose on the south side of Lincoln School, located on Wells Street, where the garages were located. Notice the school bus in the background with Erie Unified School District printed on its side. Today, Lincoln School would be in the St. Vrain Valley School District. (Courtesy EHS.)

This teacher and her students pose for a photograph in front of the brick Lincoln School. Some students seem to have dressed to have their picture taken, while others seem to be wearing what they might wear every day. Nobody is smiling in this picture. (Courtesy EHS.)

Students and teachers from the Lincoln School pose on the staircase outside the building. Of interest are the boys' hairstyles. Many seem to have let their hair grow longer while having it combed back, almost reminiscent of a later 1950s hairstyle. The boys' ties and collars seem to be bridging two generations. (Courtesy EHS.)

Sitting, kneeling, and standing, these students are dressed for pictures. Unlike some of the other photographs, this one captures many students smiling. (Courtesy EHS.)

This photograph of a teacher and her class in front of the Lincoln School appears to have been taken around the 1940s, based on the clothing styles. Apparently, the school had planted grass that it did not want anyone to walk or play on. (Courtesy EHS.)

This is an Erie miner's family in front of their cabin. It is difficult to determine if the young lady holding the infant is a young mother or an older sister. What does the older boy know that the others do not? (Courtesy EHS.)

A girl and a cat are playing in a dirt yard on Main Street on the block south of St. Scholastica's Catholic Church. This picture was likely taken in the early 1900s. Notice all of the open land west of the church; Erie High School would eventually be built in that area. (Courtesy EHS.)

This appears to be a family picnic in the late 1920s or early 1930s. They must have selected Coal Creek or Boulder Creek for this event, as trees only grew this densely near creeks in the otherwise dry, barren prairie land. (Courtesy EHS.)

This could be Erie's own Bonnie and Clyde. Based on the vegetation, they drove into the foothills west of town for a getaway. It was always a good idea to carry a shotgun for protection against wildlife. This humorous pose shows an extra set of boots belonging to one of their fellow travelers; of course, a fourth person took the picture. (Courtesy EHS.)

These women appear to be related, possibly twins. They are wearing outfits similar to what nurses wore in the 1890s and 1900s. Unfortunately, whatever they are holding in their hands is a mystery. They could also be wearing religious gowns. (Courtesy EHS.)

These two unidentified youngsters are sitting on the back of a vintage automobile with Montana license plates. The plates suggest this was taken in 1925. Notice the small trunk, narrow spare tire, and brake light. (Courtesy EHS.)

Two unidentified toddlers are posing for this scratched photograph while resting on the running board of a vehicle, possibly a truck, in the early 1900s. The older girl looks like she is wishing that her sister would stop crying. (Courtesy EHS.)

These two unidentified girls are posing for a studio photograph, likely in the early 1900s. Notice the hairstyles, high-laced boots, and dress styles. Even children of that time seemed to believe smiling was inappropriate for photographs. (Courtesy EHS.)

This young girl is posing for a photograph in the studio of someone named Stiffler in Longmont, Colorado. Her high boots, dress, and hairstyle suggest this photograph was taken around the early 1900s. The bouquet she is carrying seems to be dried flowers. (Courtesy EHS.)

Three
WHERE THEY LIVED, LEARNED, AND PRAYED

As more people moved to Erie, the town needed homes, schools, churches, stores, hotels, and other structures. By 1873, about 100 houses had been built. James L. Wilson was the primary home builder in the area. Most of the homes drew their water from three artesian wells that had been dug at Holbrook and Cheesman Streets, Moffat and Pierce Streets, and Briggs and Perry Streets. As plumbing was not as it is today, all houses had outhouses. The houses in the area were not as eclectic as today's houses; however, if one takes a tour of the town, he or she will see a blend of Victorian, Queen Anne, Italianate, Gothic, brick commercial, false-front, and hip-roofed architecture representing Erie's earliest days.

Erie's earliest school settings were likely in people's homes or businesses. The first school at Briggs and Wells Streets was built in 1874. The Lincoln School opened in 1907, with overflow classes held at the "coffin house" on Pierce Street. Because of overcrowding, the Lincoln School was remodeled in 1920, adding four new classrooms. In 1929, Erie High School was erected on Main and Cheesman Streets. In 1966, Erie Elementary School was built on County Line Road.

Erie's first church was a Welsh Methodist church, organized in 1883. Later, the English population started a Methodist Episcopal church. A Presbyterian church also served the community. James Wilson built the current Erie Methodist Church in 1888. In 1898, St. Scholastica's Catholic Church was built and dedicated in 1899. Rev. Richard van Valkenburg offered services at all of the churches, except the Catholic church.

The first jail was constructed in Erie in 1876, with Bud Pitchford serving as constable.

The west side of the 500 block of Briggs Street is still recognizable today with a little imagination. The first building on the left, with the Coca-Cola sign, is Elzi's Drugstore at 502 Briggs. Next to it is Erie Bank, now 1st Bank, at 512 Briggs Street. All of the buildings have been modified. (Courtesy EHS.)

The first building most people notice when they drive into downtown Erie today is the two-story brick commercial building at 500 Briggs Street. It was built in 1889 to house the International Order of Odd Fellows lodge upstairs and retail businesses downstairs. Today, one can still make out the lettering of the State Mercantile Company. (Courtesy EHS.)

J.T. Richards's first store was a typical false-front Western building. It is hard to tell if it was on Briggs Street or Wells Street; however, based on the construction, it matches several others built on Briggs. The wagon in front of the store likely belonged to Erie resident George Bain. J.T. Richards is the man with the moustache, vest, and arms folded. (Courtesy EHS.)

J.T. Richards's second store was a brick building on the northeast corner of Pierce and Wells streets. Notice the block near the top of the front of the building that reads "Richards 1894 Block," reflecting the date of construction. The store housed Erie's first US post office, with the mailboxes located behind the counter. (Courtesy EHS.)

On the right side of this photograph is Erie's Methodist Episcopal church on Holbrook Street at Wells. This late-Victorian, Gothic Revival–style church was built by James Wilson around 1888 to serve Erie's English population. It was the first building erected as a church in Erie. One of the church's stained glass windows was installed in memory of the Webber brothers who died in a mine accident in Utah in 1900. Another window commemorates Rev. Richard J. van Valkenburg, the man responsible for getting the church built and organizing religion in Erie. The social hall on the south side was a part of the Presbyterian church, located across Wells Street and to the south, but moved to the Methodist church site. Some claim the social hall was burned to the ground in 1951, and the area was filled in to become a parking lot.; however, Marjorie Smith recalls serving turkey dinners in the basement of the hall in the 1980s. This is one example of the differences in historical accounts about Erie. Today the site is a parking lot for the Methodist church. (Courtesy EHS.)

St. Scholastica's Catholic Church is a late-Victorian, Gothic Revival–style church, built around 1898 and dedicated in 1899. Benedictine priests established the church. Before being moved to Erie in 1957, the parish hall, located east of the church, was moved from Louisville to the Columbine Mine and to Lafayette. (Courtesy EHS.)

Erie's second town hall on Wells Street was constructed in 1930 to replace the false-front building erected in 1883. This early-20th-century commercial building housed Erie's government, fire station, correctional facility and jail, and police department. It has unique features, including a bell tower, stepped parapet, and siren tower. Today, it houses Erie's chamber of commerce. The sign above the door reads, "City Hall." (Courtesy PS.)

Erie's original schoolhouse was built in 1881 on Briggs and Wells Streets, where today's post office exists. It served more than 100 students. Overflow students were sent to classes at the coffin house, a storage facility for coffins, at 525 Pierce Street. (Courtesy EHS.)

This 1884 structure served as Erie's mortuary, an overflow classroom, a coroner's office, and a residence. It was referred to as the coffin house. It was once owned by Reverend van Valkenburg. Boulder's undertaker and coroner bought it in 1904. John Bracegirdle bought the house in 1919; he was a miner at the Puritan Mine. (Courtesy PS.)

This repaired photograph shows one of the false-front buildings along Briggs Street. Historians report that three of them were constructed next to each other and that it is difficult to identify any of them today as having served a particular purpose. Only one exists today. (Courtesy EHS.)

This false-front commercial building was erected somewhere between 1908 and 1948 as a restaurant and bar. It served as Morgan's Bar at 545 Briggs Street; although, in 1964 and 1969, city directories list it as 549 Briggs Street. Henry Corcilius may have used this as a cigar store. (Courtesy PS.)

This photograph shows the home of J.O.V. Wise on Thanksgiving Day, November 24, 1927. The number of vintage automobiles parked at the property suggests that several family members and friends may have attended this celebration. (Courtesy EHS.)

Canfield was an independent town just west of Erie. It had its own school—the Canfield School—for a period of time. However, the school does not exist today. Sarah Wise, great-granddaughter of Oliver Wise, reports having ridden her bike from Canfield to attend school in Erie. (Courtesy EHS.)

The Canfield School served Canfield's student population for kindergarten through 12th grades. The school does not exist today. Canfield's students eventually attended Erie's public schools. (Courtesy EHS.)

The house at the Wise Homestead was quite substantial for its time. The downstairs had a living room, kitchen, dining area, and bedroom. Upstairs were two bedrooms, one of either side of a staircase. For the children to exit their upstairs bedrooms, they had to pass through the parents' bedroom. Today, the home looks much like it did in the 1800s. (Courtesy EHS.)

The Lincoln School was built on Holbrook and Wells Streets, with one large room in the center and one each on the south, west, and east. It was made of bricks. Classes were held there in 1907. In 1920, four additional rooms were built on the north end of the building. It was used by grades one through 12. (Courtesy EHS.)

As the Lincoln School grew, this garage was constructed east of the schoolhouse. It was used, among other things, to park the school bus for the Erie Unified School District. It looks like a gas pump may have been installed in front of the garage. Sidewalks had been poured in this photograph. (Courtesy EHS.)

This grainy photograph shows the Lincoln School after it had been remodeled in 1920. While it appears this is the south end of the building, the actual remodeling was done on the north end of the building. The sign clearly identifies the school. (Courtesy EHS.)

Erie High School was built in 1929 to serve grades seven through 12. This took a great load off the Lincoln School. Erie Elementary School was built across the street from Erie High School in 1966, leaving the Lincoln School abandoned. Today, Erie Middle School uses the original high school building. (Courtesy EHS.)

This house at 555 Pierce Street is estimated to have been built between 1902 and 1908. The lot was owned originally by Sidney Dillon. The property was later owned by Alfred Stevens, Frank and Myrtle Taylor, John A. Freeman (a physician and drugstore owner), Rev. Richard van Valkenburg, and Walter and Margaret Lister. (Courtesy PS.)

This late-Victorian house at 485 Holbrook Street is thought to have been built around 1884 and lived in first by the John T. Williams family. Williams was a town trustee and president of the trustees in 1875–1876. Clarence Bixler moved to Erie in 1907 to open up a medical practice and bought the house from Retta Wooley around 1909. (Courtesy PS.)

This late-Victorian house at 574 High Street was built around 1894 in Erie's new subdivision called Erie Heights. Its original owners were Franklin D. and Marvel May Zook Walker. Frank was a teacher, carpenter, and mayor of Erie. Marvel was a teacher and the secretary and treasurer of the Colorado Education Association. (Courtesy PS.)

This late-Victorian house at 475 Cheesman Street was built around 1884 and is associated with J.T. Williams and John and Sarah Probert. Williams opened a general store and pharmacy and served as town trustee and treasurer. John Probert moved to Colorado to mine and, eventually, worked in Williams's store as a salesman. Sarah served Erie as a midwife and practical nurse. (Courtesy PS.)

This house at 405 Pierce Street was built in 1885 and served as the longtime home of John Harris, a coal miner from England. He bought the property from Sidney Dillon. John's daughter Jane Harris Brennan Oakley gained title to the property in 1919 and lived there until the 1970s. (Courtesy PS.)

This house at 575 Pierce Street was built sometime before the 1940s. The property transferred title from the St. Louis and Denver Land and Mining Company to Thomas Griffiths in 1881. Griffiths and others sold it to Frank and Myrtle Taylor in 1944; it then transferred to Myrtle in 1946. (Courtesy PS.)

This house at 664 Holbrook Street is estimated to have been built in 1885. J. Thomas Richards came to Erie from Ohio to work in the mines. Historians believe he may have built this house. He became a merchant. Belle Richards sold the house to her daughter Ruth Wilson in 1931. The house was in the Wilson family until 1977. (Courtesy PS.)

This house at 684 Holbrook Street was built around 1889 and originally owned by Elisha Atkins and the Union Coal Company. In 1891, Mattie E. Phennah bought it. She sold the house to Michael James and Harriet Brennan in 1917. (Courtesy PS.)

This hotel at 370 Briggs Street is estimated to have been constructed sometime between 1890 and 1892 and served Erie as a hotel until the 1990s. It has been called the Powell House, Egnew Hotel, Erie Hotel, Erie House, and Ash Pit Flophouse and Grill. It was once owned by Reverend van Valkenburg. (Courtesy PS.)

This late-Victorian, Queen Anne–style house at 704 Main Street was built in 1892. Pennsylvanian John S. Morgan was the first owner. He was Erie's postmaster and a merchant. Henry Carter bought the house in 1909. He was a Civil War veteran who came to Erie and became a grain buyer. (Courtesy PS.)

This late-Victorian, Italianate-style house at 405 Holbrook Street was built in 1892 by Enoch T. Vaughn, a coal miner. The Vaughn family lived there until 1903, when they sold it to Hugh Graham. He immediately sold it to Rachel Hunter. She held title until 1921, when she sold it to Thomas B. Hunter, associated with the Hunter Mercantile Store. (Courtesy PS.)

This late-Victorian house at 575 Holbrook Street was built in the 1880s. Robert and Martha Lawley purchased it in 1884. Robert was a founding resident and trustee of Erie. Sam Milanovich bought the house in 1938 from Martha Gossier. He lived there for 24 years. (Courtesy PS.)

This house at 455 Briggs Street was a typical hip-roofed box house of the early 1900s. William Angove, an early owner, operated the Angove and Hershey livery and feed store and a grocery store. He was a teamster and served as town treasurer. The house is also associated with the Zimmerman and Hauck families. (Courtesy PS.)

This late-Victorian house at 675 Holbrook Street was built around 1897 and lived in by families involved in coal mining. The property was originally owned by Elisha Atkins, the Union Coal Company, and the Union Pacific Railroad; the first homeowner was George Morrison, president of the Clayton Coal Company. The house was sold to Netta Wooley in 1913, Thomas Hunter in 1918, and James Charlesworth in 1919. (Courtesy PS.)

This late-Victorian house at 724 Holbrook Street was built in 1887 and lived in by James L. Wilson, a brick maker and home builder. He built many of Erie's houses and the Methodist Episcopal church. He served as mayor from 1888 to 1889 and 1915 to 1921, and he served as justice of the peace. Wilson organized a volunteer hose company. (Courtesy PS.)

This Victorian house at 745 Holbrook Street is believed to have been built in 1898. Current owner George Bachelder is restoring it. Some of the earlier families to have lived there include the Bracks, Grimsons, and Greggs. The house served as a boardinghouse for teachers at the Lincoln School. The block from the top of J.T. Richards's second store can be found in the walkway of this house. (Courtesy PS.)

Built in 1895, this late-Victorian, Queen Anne–style house at 604 High Street was built by William Nicholson, who came from England. The *Greeley Tribune* called it "the finest residence in Erie." William was involved in mining as a mine superintendent and later was the founder of Long's Peak Coal Company. He eventually sold his interest in the company to the Rocky Mountain Coal Company. William founded and served as president of the Erie Bank. He was Erie mayor in 1898–1900, 1906–1907, 1910–1911, 1914–1915, and 1929–1930. He was a member of the Masons and the Elks. He was a trustee of the Erie Methodist Church. (Courtesy PS.)

Four

A Claim to Fame

Erie is part of the Northern Colorado Coalfield, which includes Marshall, Erie Louisville, Lafayette, Niwot, Erie, Gowanda (east of Interstate 25 on Highway 66), Eastlake (Thornton Street at 128th and Claude Streets), Dacono, Frederick, and Firestone. The arid and once-treeless area encompasses 6,800 square miles. While the greater coalfield contains nearly 200 abandoned mines, the Wise Homestead Museum lists about 140. Erie supplied workers to about 47 mines.

Most of Erie's mines were close to town: Erie Parkway and East County Line Road (nine mines), Jay Road and East County Line Road (nine mines), Telleen Avenue and East County Line Road (three mines), Bonanza Drive (six mines), east of Town (16 mines), Jasper Road near Canfield (three mines), and Erie Commons (one mine). If the phrase "Erie Colorado mines" is searched for on Google, a map giving more specific locations is shown.

With the discovery of coal and the opening of mines, Erie needed a railroad spur to connect it to Denver and other communities. In 1871, Erie was served by a branch of the Union Pacific Railroad. Later, other railroads connected Erie to Boulder. A narrow-gauge railroad was built between Canfield and Longmont and operated for eight years.

Erie's Columbine Mine was the greatest source of coal in the Northern Colorado Coalfield, producing nearly 7.5 million tons of coal between 1920 and 1946. Eventually, natural gas was being piped into Colorado by Sinclair and Standard Oil companies, replacing much of the need for coal.

Many mines had opened and closed in Erie for more than 100 years since the Briggs mine opened. In 1979, the New Lincoln Mine was closed due to a fire, bringing an end to mining in Colorado's northern coalfields. Overall, about 107 million tons of coal were removed from all underground mines.

The Columbine Mine head frame was a tall structure visible for miles. It was used to support the hoist rope, which was used to lower and raise people and equipment into the mine. Notice the platform about halfway up the frame. Some historians believe this was where one of possibly three machine guns was mounted during the disturbances at the mine in 1927. Another tall structure at coal mines is the tipple, where the mine cars were placed in a large cage, tipped, and emptied of their coal into waiting railroad cars. Miners report a machine gun placed on the tipple at Columbine. A third tower is the water tower. Water was used for a variety of mining functions and, if potable, for the miners and those living at the mining camp. Miners reported seeing a machine gun on Columbine's water tower. (Courtesy EHS.)

Two Garfield Mines straddled East County Line Road where Erie Parkway is today. Garfield No. 1 was on the west side. A small tailing pile on the northwest corner of the intersection, where residue or dirt and rock were discarded after separating them from the coal, can still be seen. Garfield No. 2 was near the tennis courts and entrance to Erie Community Park. (Courtesy EHS.)

The lower half of the water tower at the Eagle Mine is still visible today as one drives west on Erie Parkway after leaving Interstate 25 at exit 232. The Eagle Mine was one of the last mines to close in 1978. Today, some Erie residents still talk about their parents and uncles working at the mine and the fires and other accidents that occurred there. (Courtesy PS.)

The Mitchell and Lloyd Mines were located near the four corners area at East County Line Road and Erie Parkway. Today, part of that land is being used to build Erie's Aspen Ridge Charter School. Allegedly,

This grainy photograph shows the water tower and many of the simple buildings at Serene, Columbine's mining camp. The other structure looks like it may have been another hoist. Miners preferred living in houses in the northern fields, as opposed to tents in the southern fields. They were actually able to cultivate gardens. (Courtesy EHS.)

the school was designed as a two-story building because a one-story with a larger footprint would result in it being built over mine shafts. The school is scheduled to open in fall 2011. (Courtesy PS.)

The Star Mine at Canfield was productive from 1883 to 1895 and was located just west of 119th Street on Jasper Road. A dirt road and Boulder Creek mark the entrance to the mine area. This scene shows a Brighton-to-Boulder train stopped for passengers and possibly coal. Another train line ran from Canfield to Longmont, along what is today's 119th Street. (Courtesy EHS.)

This miner's cabin at the Puritan Camp is one of many that still exists today in this unincorporated area between Frederick and Erie. "Shorty" and Molly Genoff lived in one of these homes around 1946. Shorty's name appears on the Erie Miner Memorial outside of Erie's Town Hall. (Courtesy PS.)

Another of Puritan Camp's cabins still stands today on Puritan Lane. These homes were provided by the Puritan Mine for many of its miners. While the original structures were only about 600 square feet, many have been remodeled to meet the needs of today's residents. (Courtesy PS.)

This miner's cabin along Puritan Lane resembles the one that Sabino "Sam" Lontine and his family lived in around 1946. Other photographs show that Sam and his wife raised three children in this home. Most of the miners in this area took pride in their company-supplied homes, furnishing them as well as they could and cultivating small gardens. (Courtesy PS.)

This miner's cabin was located along Weld County Road 7, north of US Highway 52. After the mines closed, new owners remodeled to provide the room they needed to meet their living standards. Many of the old cabins have siding and other modern additions. (Courtesy PS.)

This old cabin in Erie is one of many in the area that housed miners. Erie's miners worked in various mines, some providing housing and some not. A tour through Erie will uncover numerous housing structures that date back to the mining heyday, some seeming unfit to live in by today's standards. (Courtesy PS.)

The Clayton Mine head frame connected to another building via a conveyor belt. The frame and other structures were quite intricate for the era. It is likely that the tipple was located to the right of the other structure so the coal cars could easily be loaded into train cars. (Courtesy EHS.)

In 1887, John Simpson dug out the first shaft and started coal mining in the town of Lafayette. A part of the Northern Coke and Coal Company, the Simpson Mine was one of the most productive mines in Lafayette. Lafayette soon played a significant role in the coal-mining boom of the Northern Colorado Coalfield. (Courtesy EHS.)

This panoramic view of Serene and the Columbine Mine shows many of the buildings and structures of the camp, which included a post office, church, store, saloon, casino, brothel, miners' houses, and more. Many referred to it as a dirty little town surrounded by barbed wire. (Courtesy EHS.)

Three separate mines existed with the name Washington Mine. The oldest was located on Bonanza Drive near Sunset Drive, east of Erie Municipal Tri-County Airport. It operated from 1903 to 1911. The second Washington Mine operated from 1915 to 1918 and was basically at the same location. In fact, the Baseline, Munroe, Parkdale, and two Lincoln Mines were located along the same section of Bonanza and Sunset. Because the area was so undermined, subsidence occurred in 2007, requiring road closure and repair. The third Washington Mine opened in 1927 and operated until 1979. While this mine was located just east of Interstate 25 and north of Weld County Road 6, it is regarded as one of Erie's mines because so many of Erie's miners worked it. The Washington Mine was the last mine to close in the area, ending a prosperous era for Erie. (Courtesy EHS.)

Five

THE LEGACY THAT LIVES ON

Working at the mines was challenging. Miners typically left home and returned home in the dark, putting in 10- to 14-hour days. They worked long shifts in the dark mines in crowded, wet conditions. The air they breathed was polluted with gases and coal dust. The mine walls and ceilings sometimes collapsed; miners worked in fear that they might. Explosions killed some miners, while others were crushed between coal cars.

Weigh bosses tended to calculate the amount of coal extracted from the mines as lower than the miners actually produced. This meant the miners would take home less pay than they earned. Miners were paid in company scrip, which was only usable at company stores where they charged higher prices than stores in town. Some of the mining camps were barricaded by barbed wire and sandbags. Mine guards were armed, and some had machines guns.

When miners decided to strike for better working conditions and a voice in management decisions, mine owners authorized mine representatives to hire scab laborers who worked for lower wages and displaced regular miners.

Dissatisfaction sometimes led to miners committing acts of violence against mine property. Unions tried to intervene, but mine owners and operators would have no part of it. With the backing of the government, militia and mine guards started two massacres. One was at Ludlow in southern Colorado, and the other was at the Columbine Mine in Erie.

Following a great deal of conflict, the Rocky Mountain Fuel Company's owner, Josephine Roche, understood the wishes of miners and permitted miners to unionize at her company. This led to the eventual mandate from President Roosevelt that all mines be unionized.

Unbeknownst to the miners, union officials, and Roche, the struggles in the mining industry led to business owners being concerned about production as well as people. This management model is what defines some of today's most successfully run companies.

This rock contains a mine marker of the Boulder Valley Mining Company. It is located about 200 feet east of Coal Creek slightly south of Cheesman Street. Other markers can be found along the creek area. (Courtesy PS.)

This miner's cabin and coal car are located in Marshall, one of the first towns in the northern Colorado coal field to mine coal. After Marshall was mined out, residents experienced subsidence all over the area. Nothing was done to mitigate the effects of open mines under the town. (Courtesy PS.)

The Chase Mine operated from 1892–1895 and was located just east of the intersection of Telleen and Meller Avenues. Today, this area is the site of Erie's newest school, Red Hawk Elementary, with an expected opening date of fall 2011. Other mines also operated in the nearby vicinity. The school was constructed as a two-story building to avoid being built over any abandoned mine shafts. (Courtesy PS.)

Carol Taylor, librarian at the Erie Community Library, displays a chunk of coal from the Northern Colorado Coalfield. This sample contains more bitumen than lignite coal. Lignite has a higher carbon and liquid content, making it more unstable for storage or transport. One can view this coal chunk in the display at the library. (Courtesy PS.)

The Eagle Mine was located at the crossroads of where Erie Parkway and Interstate 25 cross today. One can see the remains of the water tower just to the right of the sign marking the eastern boundary of Erie. Operating from 1939 to 1978, it was one of the last mines to close in the Northern Colorado Coalfield. This photograph of the day shift at the Eagle Mine was taken

The Boulder Valley Mine operated from 1917 to 1947. It was located just west of Weld County Road 5, south of Erie Parkway, and close by to the Columbine and State Mines. This photograph shows the top crew at the mine. Notice that many of the miners are older and still performing this hazardous, arduous work. (Courtesy EHS.)

around 1941–1942. The miners were dressed to get dirty; in fact, some of their shirts in this picture show just how dirty they got. They all wore head lamps. Notice the buildings with their chutes, staircases, shapes, and wires to support various structures. The technology of the industry at that time had its own definition and precision. (Courtesy EHS.)

This picture was taken in 1942 of the Rocky Mountain Fuel Company (RMFC) day shift at the Columbine Mine. RMFC's controlling stockholder at this time was Josephine Roche; she was sympathetic to miners' concerns and was the first mining company owner to allow its miners to become unionized. (Courtesy EHS.)

The State Mine operated from 1913 to 1916. If one drives south from Erie Parkway on Weld County Road 5, the tailing pile from the State Mine will be noticeable. If one turns right on the road to the landfill, the area of the State, Boulder Valley, and Columbine Mines will be visible. Here, miner Louis Regnier poses with family members at the State Mine. (Courtesy EHS.)

The two Regnier boys posed near a coal car on its tracks, while the rest of the family stayed in the background. Humans pulled coal cars in the earliest days, often by women and children. Later, mules proved to be reliable, both underground and outside. With improved technology, tracks were laid and coal cars were fitted with the appropriate wheels. (Courtesy EHS.)

Here is a group of miners with their mules. Mules were used to pull the coal cars even after electric pulleys were designed for the job. Because of the gases and dust in the mines, people feared that an electric spark might cause an explosion. Mine builders often graded the mine floors to ease the burden on the mules. (Courtesy EHS.)

Coal cars were made of heavy cast iron. When they were filled with coal and not anchored, they were a hazard to miners. Several Erie miners were killed when they were trapped between runaway coal cars and another stationary object. These coal cars are displayed at Coal Miner Park in Erie. (Courtesy PS.)

Lou Liley, left, and another miner posed at the mine head at the Liley Mine. This mine was located in Lafayette. It was east of where the Exempla Hospital is today and west of the housing development off of Dillon Road at Sheridan Parkway. (Courtesy BL.)

Lou Liley, left, and another miner posed in a coal car on tracks next to logs used to support the mine walls and ceilings. The Liley Mine operated from 1937 to 1948 and was one of several successful mines in the Lafayette area. The Lafayette Miners Museum is a great source of information and mine relics. (Courtesy BL.)

These two miners posed for a photograph on their way to or from work. They are wearing miners' lamps and carrying picks and the lunch buckets. Most of the boardinghouses in Erie included a daily bucket lunch for miners as part of their room rates. One of the miners appears to have a cigar in his mouth but was likely not allowed to smoke in mine. (Courtesy EHS.)

The National Fuel Company First Aid Team No. 13 was an advancement made following strikes for improved working conditions at the mines. Pictured here, from left to right, are team captain Pat McCarthy, Jules Regnier, Andrew Heaton, George Swallow, Jack Tierney, and K.P. Hewlett. (Courtesy EHS.)

Many relics are still visible today of the mining and farming era in the northern Colorado coal field. A brief tour through Marshall will show visitors numerous tractors and other pieces of old machinery, coal mining equipment, and miners' cabins. (Courtesy PS.)

Perhaps the most tragic event in Erie's history is the Columbine Mine massacre on November 21, 1927. Six unarmed striking miners were gunned down by Colorado militiamen, some firing machine guns. Five of the miners are buried in Lafayette's cemetery, and the sixth is buried in Louisville. (Courtesy PS.).

Six

A Great Place to Live

Following the Great Depression and the closing of most of the mines, Erie began to deteriorate, and miners and businesses left. The railroads discontinued their service to town. The trees died because of the cost of maintaining them, and there was a grasshopper plague in 1933. Slowly, the town turned into a sleepy community where saloons outnumbered churches. Most of the residents seemed to prefer their solitude.

From the late 1970s until today, Erie has annexed numerous properties and now covers an area of 48 square miles, about the size of the city of San Francisco. With 19,000 people and lots of open space, Erie still feels like a country town. Town leaders are still unsure about how large Erie will grow in what amount of time. Estimates ranged from 30,000 to 100,000 residents. Those are probably short- and long-term possibilities.

In 2005, Erie High School moved to a large, new campus at Weld County Road 5 and Erie Parkway. In 2007, the Wise Homestead Museum opened to the public. In 2008, Erie had ribbon-cutting ceremonies for its new Erie Community Center, Erie Community Library, and Black Rock Elementary School. In 2010, Erie Community Park opened and plans are underway for a second phase. Two more elementary schools are under construction in 2011.

A few small shopping centers have opened in Erie in the past few years. Erie still has only one grocery store and a few restaurants. Some people complain that Erie is growing too fast, but the reality is that new businesses and government services will not come to Erie without a certain critical mass of people. Erie provides a strong sense of community. People often use the "small world" cliché when they begin to discuss similar acquaintances and experiences.

Erie is truly a great place to live. As the town's motto goes, "Your Future is Here."

Erie became somewhat of a ghost town in the late 1970s, after most of the mines were closed. Erie's 1st Bank opened on June 29, 1972. The newest car in this photograph is a 1975 or 1976 model. The State Mercantile Building at 500 Briggs and the Elzi Drugstore are both boarded-up. (Courtesy EHS.)

In 1938, the town of Erie received its first airmail delivery at the Erie Tri-County Municipal Airport. The airport has a colorful history, based on reports from town hall. It used to be the home of a restaurant fashioned from an old airplane. (Courtesy EHS.)

This aerial view of Erie was taken around 1946 or 1947. The block with the greatest number of cars is Briggs Street, with the two-story IOOF Hall and State Mercantile Building on the northwest corner at Moffat Street. This picture must have been taken some time between late fall and early spring. (Courtesy EHS.)

This aerial view of Erie is believed to have been taken in the 1960s, sometime after 1966, when Erie Elementary School was built. Notice the increased vegetation in this photograph compared to the previous one. In the foreground is East County Line Road with the high school and elementary school across the street from each other. (Courtesy EHS.)

The Erie Miners Memorial was dedicated in 2000. It stands outside of town hall on Holbrook Street. It shows the names of about 525 miners who worked in Erie's mines. The names are not in any particular order. The memorial is updated as people report new names. (Courtesy PS.)

The Columbine Mine Memorial is located on Colorado Highway 7 near the east end of Anthem in Broomfield. The memorial commemorates the history of mining in Erie and those who died at the Columbine Mine Massacre in 1927. It also contains a picture of the gravestone in Lafayette's cemetery for five of the people killed. The sixth person killed was buried in Louisville. (Courtesy PS.)

Erie has not built any large malls; although, there is one shopping center at US Highway 287 and Arapahoe Road. A few smaller shopping strips have begun to be developed. This one is on Erie Parkway near where the Mitchell and Lloyd Mines used to operate. The center houses the Parkway Grill and Snowcap restaurants, a beauty salon, and dentists' offices. (Courtesy PS.)

Another shopping center was built recently between Erie Parkway and Briggs Street. It is the home of Lui's Wok and Grill, dentists' offices, Summit Bank, Edward Jones, Van Lone Real Estate, a beauty salon, and a few other businesses. This seems to be how Erie will develop until its population increases. (Courtesy PS.)

The Erie Community Library opened in 2008 as a full-service library. It has a large collection of books, cassettes, CDs, and DVDs. This branch of the High Plains Library District provides many computer stations, meeting rooms, and a lovely reading room with a fireplace. (Courtesy PS.)

The Erie Community Center opened in 2008, with swimming pools, a lazy river, water slides, a gymnasium with basketball and volleyball courts, fitness area on two levels, an indoor track, racquetball courts, climbing walls, child care, a kitchen, meeting rooms, and more. (Courtesy PS.)

The Erie Community Park opened in 2010, adjacent to the community center and library. This 41-acre park includes four lighted baseball and softball fields, four lighted tennis courts, three playgrounds, a multipurpose field, and a picnic shelter. A second phase of the park is underway, with plans for an amphitheater, another playground, and more parking. (Courtesy PS.)

In 2005, Erie High School opened at its new location at Erie Parkway and Weld County Road 5. It provides state-of-the-art classrooms, laboratories, computer rooms, baseball and softball diamonds, a lighted football stadium, tennis courts, and more. (Courtesy PS.)

This sign marks Erie's Mount Pleasant Cemetery. While only visitors can appreciate the view, those interred as cemetery residents are located in a peaceful, isolated section of the town. Approximately 1,000 people are registered as buried there, but town officials know the number is much greater. (Courtesy PS.)

St. Luke Orthodox Christian Church was completed in 2010. Because of its size and location, it serves as somewhat of a beacon for those arriving to town at Austin Avenue and East County Line Road. It is the largest Antiochian Christian church in Colorado. (Courtesy PS.)

The town of Erie has grown in size since it was first platted. It now encompasses about 48 square miles, with boundaries of Interstate 25 to the east, US Highway 287 to the west, Colorado State Highway 52 to the north, and Colorado State Highway 7 to the south. It is about the size of San Francisco. This rectangular town area still contains a great deal of open space and some unincorporated land. During the 1960s, Erie's leaders began annexing different parcels of land. Over time, they have become more aggressive with annexation. The towns of Broomfield, Frederick, and Lafayette own corners of the Erie rectangle. Erie has plans to build more housing areas and increase its population to attract businesses and government services for its residents. Many residents, especially those living in downtown Erie, would prefer to see the town stay small, but they also realize the value in planned, moderate growth. (Courtesy TE.)

The old Lincoln School sat vacant from 1966, when Erie Elementary School was built, until it was renovated in 1998, when it became the new town hall for Erie's government. The building is in the National Register of Historic Places. (Courtesy PS.)

Signs marking Erie's town limits have been posted at Erie Parkway at the Interstate 25 intersection and on Arapahoe Road at US Highway 287. As Erie continues to grow, it is a great place to live. Town leaders have adopted the motto, "Your Future is Here." (Courtesy PS.)

BIBLIOGRAPHY

Dyni, Anne Quimby. *Erie, Colorado: A Coal Town Revisited*. Erie, CO: The Town of Erie, 2001.
May, Lowell, and Myers, Richard, eds. *Slaughter in Serene: The Columbine Strike Reader*. Denver, CO: Bread and Roses Cultural Center; also Philadelphia, PA: Industrial Workers of the World, 2005.
McGinn, Elinor. *A Wide Awake Woman: Josephine Roche in the Era of Reform*. Denver, CO: Colorado Historical Society, 2002.
Michener, James A. *Centennial*. New York, NY: Random House Trade Paperbacks, 1974.
Ogle, George Ewing. *The Price of Colorado Coal: A Tale of Ludlow and Columbine*. Bloomington, IN: Xlibris Corporation, 2006.
Simmons, R. Laurie and Simmons, Thomas H. *Erie, Colorado Historical Buildings Survey 2009–2010: Final Survey Forms*. Denver, CO: Front Range Research Associates, Inc., 2010.
Simmons, R. Laurie and Simmons, Thomas H. *Erie, Colorado Historical Buildings Survey 2009–2010: Final Survey Report*. Denver, CO: Front Range Research Associates, Inc., 2010.
Smith, Phyllis. *Once a Coal Miner: The Story of Colorado's Northern Coal Field*. Boulder, CO: Pruett Publishing Company, 1989.
Ubbelohde, Carl, Benson, Maxine, and Smith, Duane A. (2006). *A Colorado History* (9th Ed.). Boulder, CO: Pruett Publishing Company, 2006.

www.arcadiapublishing.com

Discover books about the town where you grew up, the cities where your friends and families live, the town where your parents met, or even that retirement spot you've been dreaming about. Our Web site provides history lovers with exclusive deals, advanced notification about new titles, e-mail alerts of author events, and much more.

MADE IN THE USA

Arcadia Publishing, the leading local history publisher in the United States, is committed to making history accessible and meaningful through publishing books that celebrate and preserve the heritage of America's people and places. Consistent with our mission to preserve history on a local level, this book was printed in South Carolina on American-made paper and manufactured entirely in the United States.

This book carries the accredited Forest Stewardship Council (FSC) label and is printed on 100 percent FSC-certified paper. Products carrying the FSC label are independently certified to assure consumers that they come from forests that are managed to meet the social, economic, and ecological needs of present and future generations.

FSC
Mixed Sources
Product group from well-managed forests and other controlled sources
Cert no. SW-COC-001530
www.fsc.org
© 1996 Forest Stewardship Council

Find Your Place in History.